# PIONEERS OF CONTEMPORARY GLASS

# PIONEERS OF CONTEMPORARY GLASS

## Highlights from the Barbara and Dennis DuBois Collection

Cindi Strauss

with Rebecca Elliot
and Susie J. Silbert

THE MUSEUM OF FINE ARTS, HOUSTON

DISTRIBUTED BY YALE UNIVERSITY PRESS,
NEW HAVEN AND LONDON

© 2009 The Museum of Fine Arts, Houston
All rights reserved.

This book may not be reproduced, in whole or in part, including illustrations, in any form (beyond that copying permitted by Sections 107 and 108 of the U.S. Copyright Law and except by reviewers for the public press), without written permission from the publisher.

This catalogue was published to coincide with the exhibition *Pioneers of Contemporary Glass: Highlights from the Barbara and Dennis DuBois Collection* at the Museum of Fine Arts, Houston, March 7–July 26, 2009.

Generous funding is provided by:
Mr. and Mrs. Louis K. Adler
Art Alliance for Contemporary Glass
Anne Lamkin Kinder
Houston Studio Glass –
  Richard Moiel and Katherine Poeppel

Publications Director: Diane Lovejoy
Editorial Manager: Heather Brand
Designed by Phenon Finley-Smiley
Printed in the United States of America
Photography by Thomas R. DuBrock,
  unless otherwise noted

Distributed by Yale University Press,
New Haven and London
www.yalebooks.com

Library of Congress Cataloging-in-Publication Data

Pioneers of contemporary glass : highlights from the Barbara and Dennis DuBois collection / Cindi Strauss, with Rebecca Elliot and Susie J. Silbert.
      p. cm.
    Issued in connection with an exhibition held at the Museum of Fine Arts, Houston, from March 7–July 26, 2009.
    Includes bibliographical references.
    Summary: "Traces the development of the studio glass movement with entries on 30 outstanding works by 26 international artists, an essay, and an interview with the collectors" —Provided by publisher.
    ISBN 978-0-300-14695-0 (pbk. : alk. paper)
    1. Studio glass—Private collections—United States—Exhibitions.  2. DuBois, Dennis—Art collections—Exhibitions.  3. DuBois, Barbara—Art collections—Exhibitions.  I. Strauss, Cindi. II. Elliot, Rebecca E.   III. Silbert, Susie J.   IV. Museum of Fine Arts, Houston.
  NK5103.D83P56 2009
  748.074'7641411—dc22
                  2008074057

Cover illustrations: (front) Marvin Lipofsky, *Kentucky Series #8* (detail), 2000–2001; (back) František Vízner, *Untitled* (detail), 1993.

Page 2: Lino Tagliapietra, *Batman* (detail), 1998.

Page 6: Fujita Kyohei, *Taketori Tale* (detail), 2000.

Page 18: Dale Chihuly, *Untitled* (detail), from the *Seaform* series, 1989.

Page 84: Dan Dailey, *Fool* (detail), from the *Individuals* series, 2004.

Page 88: Toots Zynsky, *Lady in a Blue Chair,* (detail), from the *Tierra del Fuego* series, 1990.

# CONTENTS

# FOREWORD

*Pioneers of Contemporary Glass: Highlights from the Barbara and Dennis DuBois Collection* is the first exhibition devoted to contemporary studio glass at the Museum of Fine Arts, Houston (MFAH). It underscores the museum's commitment to collecting, exhibiting, and creating programs for contemporary art in all media.

Barbara and Dennis DuBois have assembled a breathtaking collection of international sculptural glass over a period of twenty years, and their passion for glass has been all-encompassing. In their pursuit of excellence, they have traveled the world visiting artists' studios and have attended numerous conferences to increase their knowledge of artistic glass.

The works included in this exhibition demonstrate the creativity, wide range of aesthetics and forms, and innovative techniques in glass. The artists are committed to exploring and testing the boundaries of the medium. While it is impossible to briefly survey the breadth of studio glassmaking over the course of its four-decade history, the DuBoises' collection highlights the most important developments and themes in the field.

This exhibition would not be possible without the generosity and participation of Barbara and Dennis DuBois. They have been model colleagues, and their enthusiasm for glass has been contagious. The MFAH would like to extend its appreciation and thanks for this incredible opportunity.

PETER C. MARZIO
DIRECTOR
THE MUSEUM OF FINE ARTS, HOUSTON

# ACKNOWLEDGMENTS

In April 2005, on the occasion of the exhibition *Mary Shaffer: Reflecting Light* at the Houston Center for Contemporary Craft, I had the opportunity to meet Barbara and Dennis DuBois, Dallas-based collectors who had lent a number of magnificent works to the exhibition. That first meeting led to an invitation for Peter C. Marzio, director of the Museum of Fine Arts, Houston (MFAH), and me to visit the DuBoises in Dallas. This subsequent visit led to the planning of the *Pioneers of Contemporary Glass* exhibition and catalogue, which feature thirty examples of studio glass chosen from the DuBoises' extensive collection.

Barbara and Dennis DuBois have been instrumental in every step of this project. They shared their deep love for glass with me, provided unfettered access to their collection, and happily answered a myriad of questions. To them, I would like to extend my great thanks. It has been a pleasure to work with them and an honor to show their collection at the museum.

I would like to thank Peter C. Marzio and the museum's Board of Trustees for their support of this project. Although the museum has steadily been exhibiting glass in its galleries, this is the first show dedicated solely to contemporary glass at the MFAH. On behalf of the museum, I would also like to thank Mr. and Mrs. Louis K. Adler, the Art Alliance for Contemporary Glass, Anne Lamkin Kinder, and Houston Studio Glass – Richard Moiel and Katherine Poeppel for their generous support of this exhibition and catalogue.

Many museum staff members have worked diligently on this project. I would like to thank Diane Lovejoy, publications director, Heather Brand, editorial manager, and Phenon Finley-Smiley, designer, for their excellent stewardship of the catalogue. Thomas R. DuBrock contributed the marvelous photographs, and Marty Stein, image librarian, ensured their ready usage. In the registrar's office, Julie Bakke, chief registrar, Kathleen Crain and Heather Schweikhardt, exhibitions registrars, and Jane Gillies and Rachel Sabino-Gunaratna, object conservators, deserve thanks for coordinating the

safe travel of these fragile objects from Dallas to Houston. Bill Cochrane designed the spectacular installation and lighting, which was no easy feat, considering the material. I would also like to thank Miranda Warren, departmental assistant, for holding all of us together with good humor and great cheer.

I owe a debt of gratitude to my co-authors, Rebecca Elliot, curatorial assistant for the department of modern and contemporary decorative arts and design, and Susie J. Silbert, Windgate Charitable Foundation intern. In addition to writing for the catalogue, Rebecca coordinated numerous tasks related to the exhibition. Susie, a glass artist and scholar, contributed essential knowledge about the artists, techniques, and the history of glass. It is fair to say that this catalogue and exhibition would not be what they are without her.

Finally, I would like to thank Corning Museum of Glass curator Tina Oldknow and the artists in the collection who provided crucial insight into their work. Their help was invaluable and gave me the confidence that I needed to enter this demanding yet rewarding field.

CINDI STRAUSS
CURATOR, MODERN AND CONTEMPORARY DECORATIVE ARTS AND DESIGN
THE MUSEUM OF FINE ARTS, HOUSTON

# COLLLECTORS' STATEMENT

Our collection has grown a great deal since that fateful 1985 winter day in Toronto when I purchased two unique perfume bottles from Sandra Ainsley. Barbara liked them, and so on the next occasion, I bought her another. Through Sandra, we were soon exposed to sculpture, and we bought our very first piece in 1986. For the reasons we discuss in the interview in this catalogue, we were immediately captivated and began to collect with zeal.

Of course, at that time, we had no idea what we were doing. We did not know blown glass from cast glass—in fact, we probably did not know that cast glass existed, or lampworked glass or cold-worked glass, or any other of the variations. We did not know how glass was made; we had never heard of annealing. Probably the only thing we knew was that it would break if we dropped it. Yet, amazingly, our collection contains relatively few mistakes. How did that happen? A little luck perhaps, but much more important, it was the education and advice that we received from the gallery owners. Every one of them contributed to our knowledge by patiently explaining the processes and techniques involved in making a particular sculpture, giving us insight into the artist's background, and guiding us to the best pieces available. Many times we were gently pushed from our selections to pieces that the gallery owner believed to be more sophisticated, groundbreaking, or just more significant. These pioneers in this new medium had the foresight to do what was right for the collector and right for the art form.

This catalogue is a tribute to them because this collection in large part belongs to them.  We thank you—Sandra Ainsley, Linda Boone, Kate Elliott, Ferd Hampson, Doug Heller, Kenn Holsten, Scott Jacobson, Bonnie Marx and Ken Saunders, and Ruth Summers. Of course, our naming the owners is not intended to exclude all the wonderful staff at each of these galleries.

Also, we would like to add a special thanks to Dr. Ted Pillsbury, the former director of The Kimball Art Museum in Fort Worth, Texas. Several years ago, Ted visited our collection at the urging of a good friend. He immediately saw what we had seen—wonderfully creative works of fine art—and he took it upon himself to spread the word. He brought numerous groups to our home, his graduate students, family, Dr. Steve Nash, then director of the Nasher Sculpture Center in Dallas, and, most important, Dr. Peter C. Marzio and Cindi Strauss from the Museum of Fine Arts, Houston.

We have learned that, for both the collector and the museum, the process of mounting an exhibition is a long, complicated, and stressful undertaking—one that, in the case of glass, is fraught with risk. Peter and Cindi have made it an enjoyable and educational experience, and we thank them for the opportunity to share a part of our collection with you.

BARBARA AND DENNIS DUBOIS

# CONTEMPORARY STUDIO GLASS: A BRIEF HISTORY
by Cindi Strauss

In a 1988 article published in *Glass Art Society Journal,* Corning Museum of Glass curator Suzanne K. Frantz provocatively called into question the definition of studio glass in the United States by asking: "Just what are we talking about when we say studio glass? Is it exclusively blown glass? What about engraved, lamp worked, cast, painted, and stained glass? . . . Is studio glass made only by an artist working alone? How many people [are] working completely by themselves? . . . More can be accomplished techni-cally by collaboration . . . Does the fact that . . . dozens of . . . artists work directly with glass craftspeople necessarily make the end result, their art, any less worthwhile than if it had been made with their own hands?"[1] In posing these queries, Frantz verbalized a discussion that still resonates today. The answers then, as now, are varied depending on the point of view. For as the pieces in the Barbara and Dennis DuBois Collection attest, studio glass cannot be defined as any one type of glass made in any one specific environment by any one person. Rather, the diversity of creativity, aesthetics, technique, scale, and form seen today is only possible through a myriad of approaches, all of which are facets of studio glass.

Art-history narratives often begin with pioneering artists who set out to create a new art form. As a field grows, and as research is undertaken and information is disseminated, historians begin to contextualize the narrative, challenging accepted ideas and ultimately proposing a multilayered, more complex story. The history of studio glass is no different.

For many, studio glass began in 1962, when the artist Harvey Littleton, Dominick Labino, then vice president and director of research at Johns-Manville Fiber Glass Corporation, and Harvey Leafgreen, a retired blower from Toledo's Libbey Glass Works, held the first workshops in glassblowing at the Toledo Museum of Art.[2] However, prior to this event, a handful of artists, including Edris Eckhart, Maurice Heaton, and Frances and Michael Higgins in the United States and Jean Sala in France, had been experimenting with fusing, slumping, or lampworking glass in a studio environment in the years after World War II.[3]

Nevertheless, in the United States, the importance of the Toledo Workshops, as they are known, cannot be overstated. In March 1962, Littleton, Labino, and Leafgreen, along with seven official student participants, achieved the improbable. They built a furnace for the preparation of molten glass and, using #475 glass marbles from the Johns-Manville company, blew a glass bubble, thus marking the birth of the studio glass movement in America. A second workshop, held in June, had a more ambitious schedule but the same goal: the students aimed to create blown-glass objects on their own in a studio, rather than factory, environment.

The Toledo Workshops launched more than a new field in America; they put forth a specific definition for the studio glass movement that focused solely on blown glass made by an artist working alone who had a commitment to expanding the knowledge of glassmaking through a university environment. Littleton and his followers deliberately distanced themselves from the factory environment and the hobbyist, thereby establishing an identity and parameters for this new movement. The results were profound. Following Littleton's lead at the University of Wisconsin–Madison, university and craft-school programs in glass were established at the University of California, Berkeley (1964), the Rhode Island School of Design (RISD) (1965), the Penland School of Crafts (1967), the University of Toledo (1969), and the Philadelphia College of Art (1970), among others. By 1973, glass programs were so ubiquitous in universities and in the craft world that *Glass Art Magazine* listed seventy educational programs, most offered within university art departments.[4]

The artists who led these early programs frequently had direct ties to Littleton and Labino, either through Wisconsin or Toledo. Dale Chihuly, a graduate student of Littleton's at Wisconsin, assisted Norman Schulman in leading the program at RISD. Marvin Lipofsky, another graduate student of Littleton's, founded the program at Berkeley, and Fritz Dreisbach, who spent a great deal of time at Toledo thanks to Dominick Labino, taught at the program there. In turn, these artists' students, including Richard Marquis, Dan Dailey, and others, established glass programs at other universities, thereby extending the chain of influence promulgated by Littleton.

After the success of the Toledo Workshops and the university programs in glassmaking that they had spawned, perhaps one of the most important factors in the development of the American studio glass movement in the 1960s and 1970s was the steady stream of opportunities for American glass artists to study in Murano. Italian glass factories offered firsthand exposure to centuries-old traditions and techniques that were essential knowledge for any craftsperson eager to work with molten glass. Though the Italian glassworks were factories, they were not creating mass-produced works in a mechanized, industrial manner. Rather, each piece, although created in repetition, was made by hand by a team of skilled workers led by a *maestro*, whose mastery of glassmaking techniques made possible the fabrication of exceptional artistic glass. Lino Tagliapietra, a *maestro* who in the second half of his career turned to a studio environment, recently remarked that having to repeatedly reproduce a single design perfectly in the factory was more difficult than creating even his most complex studio pieces.[5]

Beginning in the late 1950s, American artists found a welcoming environment at the legendary Murano factory Venini & C.[6] When Ludovico Diaz de Santillana, an architect and the son-in-law of founder Paolo Venini, assumed leadership of the factory upon Venini's death in 1959, he welcomed the fresh perspectives that outsiders could provide, thereby continuing a tradition established by his father-in-law.[7] Fortunately for American artists, Fulbright scholarships often provided the funds for them to successfully complete a residency. Indeed, artists such as Thomas Stearns, Dale Chihuly, Richard Marquis, and Dan Dailey were among those who studied at Venini with Fulbright support.  Other artists such as James Carpenter, Benjamin Moore, Marvin Lipofsky, and Toots Zynsky also had residencies at Venini between the early 1970s and mid-1980s, however, their financial support came from other sources.

At Venini, some of these visiting American artists simply observed the *maestros* on the factory floor; some designed for production; and others actively participated as members of a glassblowing team.[8] Regardless of their individual experiences, at the end of their time in the factory, these artists understood that artistic glass could be made by a team in addition to being produced by an individual alone. This scenario was diametrically opposed to the teachings of Harvey Littleton and would dramatically change the course of American studio glass. Venini's choreographed collaboration,

specialization of skills, and departments for cold-working and finishing provided a new model for studio glass. Intent on duplicating the success seen at Venini, early visitors like Chihuly, Carpenter, and Marquis disseminated the lessons they had learned there throughout the United States, thereby offering another pathway for emerging American glass programs and the artists they trained.

The Italians' role in aiding the development of studio glass in America was not the only European influence on the field. As glass history has been reevaluated, the role of German and Czech artists in the studio-glass narrative has become known, and the contributions of artists in countries such as Sweden, Finland, and the Netherlands continue to be examined. Among the European glass artists of the 1960s, Erwin Eisch stands out for his early and radical rejection of traditional glass vessels in favor of an expressive, sculptural form that allowed for emotional, political, or narrative content within glass.[9] In what can be described only as a fortuitous occurrence, Harvey Littleton, on a 1962 exploratory trip to Europe that took place just prior to the Toledo Workshops, met Eisch and found a kindred spirit. Their friendship had a significant effect on the development of studio glass both in the United States and Germany. Eisch presented his philosophy and undertook demonstrations at both the 1964 World Congress of Craftsmen in New York and at Littleton's program at the University of Wisconsin–Madison. His rejection of the medium's favored characteristics—transparency and optical illusion—and his focus on the material's conduct during the melting and solidifying process proved to be of seminal importance to the rapidly developing field.[10] In turn, Littleton's breakthrough of working with hot glass in a studio setting inspired Eisch to establish his own glass studio, one of the first in Europe.

In the former Czechoslovakia, the widespread prominence of glass schools, which trained designers for industry in the first half of the twentieth century, allowed for the continuing education of future glass artists in the face of political turmoil after 1948. While ostensibly educating their students for future employment as designers in the glass companies, two influential professors at the Academy of Applied Arts in Prague, Josef Kaplický and Karel Štipl, advocated for a more sculptural approach to glassmaking.[11] In particular, Kaplický's encouragement of independent creative expression and the use of casting techniques, and Štipl's focus on sculptural and architectonic

forms that could be enhanced by relief-cutting, set the stage for the foundation of Czechoslovakia's artist-driven glass movement. In fact, in the 1970s and 1980s, under the direction of Stanislav Libenský, who had assumed leadership of the Academy of Applied Arts program, students paid increased attention to the technique of mold-melted glass and built their own studios equipped with electric glass-melting furnaces.[12] This pioneering technique was widely disseminated to the international glass community by Libenský, his wife Jaroslava Brychtová, and their students after the fall of Communism in that country in 1989.

The international exchange of ideas among glass artists was at its peak in the 1980s. In addition to workshops held at university programs and craft schools, the Pilchuck Glass School in Stanwood, Washington, hosted visiting artists both formally and informally. Founded by Dale Chihuly and the collectors John and Anne Hauberg in 1971, Pilchuck has a history that is inextricably intertwined with the rise of studio glass in the United States, and it remains an important training ground for glass artists to this day.[13] In the 1980s, international glass artists such as Bertil Vallien and his wife, Ulrica Hydman-Vallien, Klaus Moje, Lino Tagliapietra, Erwin Eisch, Jochem Poensgen, Finn Lynggaard, Stanislav Libenský and Jaroslava Brychtová, Dana Zámečniková, and Ann Wolff were among those who visited Pilchuck, working alongside established American artists as well as students.

Today, the studio-glass community continues its open-door policy, with artists from around the world regularly traveling to each other's studios and offering workshops and lectures at educational institutions. Conversation is less about excluding work from the definition of studio glass and more about inclusiveness and the recognition of the field's growth as an art form. The ongoing dialogue about techniques, materials, tools, and aesthetics, once the province of practitioners, has been augmented by a growing chorus of critical writing about contemporary glass and its origins. Added to this mix is a thriving community of collectors and galleries, and an increase in museum exhibitions devoted to the medium. Studio glass has reached a point of collective convergence, embracing these multiple dialogues and narratives, while also offering a way to examine its various facets individually within a broader, cohesive context. The diversity of the movement is reflected in the works of the Barbara and Dennis DuBois Collection, and in

the pioneering accomplishments of the artists featured in these pages. The answers to Frantz's questions of two decades ago may never be agreed upon, but perhaps the questions are more crucial than the answers. For it is in this line of questioning, in this search to define itself, that the studio glass movement has evolved—and will continue to do so.

## Notes

1    Suzanne K. Frantz, "Not so New in '62," *Glass Art Society Journal* (1988): 15.

2    Martha Drexler Lynn provides a thorough history of Littleton's and Labino's backgrounds and of the years leading up to the Toledo Workshops in her book *American Studio Glass 1960–1990* (New York: Hudson Hill Press, 2004), 49–67.

3    Suzanne K. Frantz discusses additional artists who were working artistically with glass as well as the pioneering works of the French artist Maurice Marinot at the turn of the twentieth century in her book *Contemporary Glass: A World Survey from the Corning Museum of Glass* (New York: Harry N. Abrams, 1989).

4    Ibid., 60.

5    Lino Tagliapietra, conversation with the author, October 13, 2008.

6    For a discussion of the relationship between American artists and the Venini factory, see Suzanne K. Frantz, "The Italian Connection: Americans at Venini," in *Viva Vetro! Glass Alive! Venice and America* (Pittsburgh: Carnegie Museum of Art, 2007), 20–33.

7    Ibid., 20–21.

8    Frantz provides a detailed narrative of each artist's experience in ibid.

9    Helmut Ricke, *Glass Art: Reflecting the Centuries* (Munich: Prestel, 2002), 257.
      Also see Susie J. Silbert's commentary on Eisch, page 31 of this catalogue.

10   Ibid.

11   Antonín Langhamer describes Kaplický's and Štipl's history and time at the Academy of Applied Arts in detail in "Czech Specialized Schools for Glassmaking and Schools of Applied Arts: 1945–1990," in *Czech Glass 1945–1980: Design in an Age of Adversity*, ed. Helmut Ricke (Stuttgart: Arnoldsche Art Publishers, 2005), 47–57.

12   Ibid., 56–57.

13   For a complete history of Pilchuck, see Tina Oldknow, *Pilchuck: A Glass School* (Seattle: University of Washington Press, 1996).

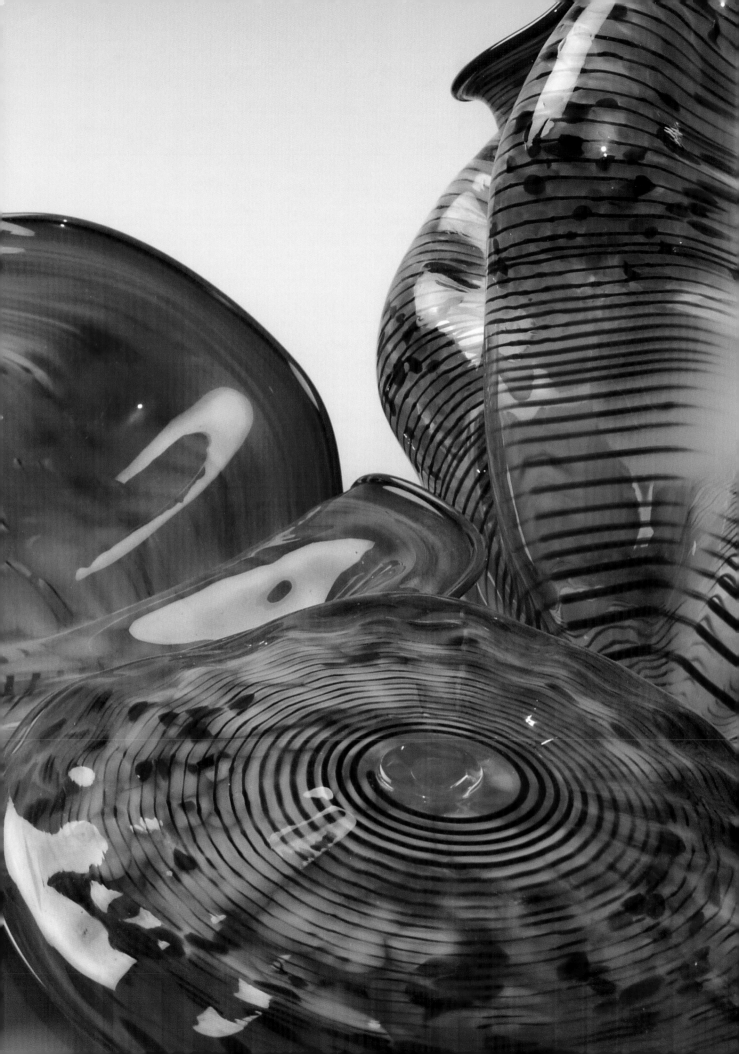

# FEATURED WORKS

WITH COMMENTARY BY
REBECCA ELLIOT, SUSIE J. SILBERT, AND CINDI STRAUSS

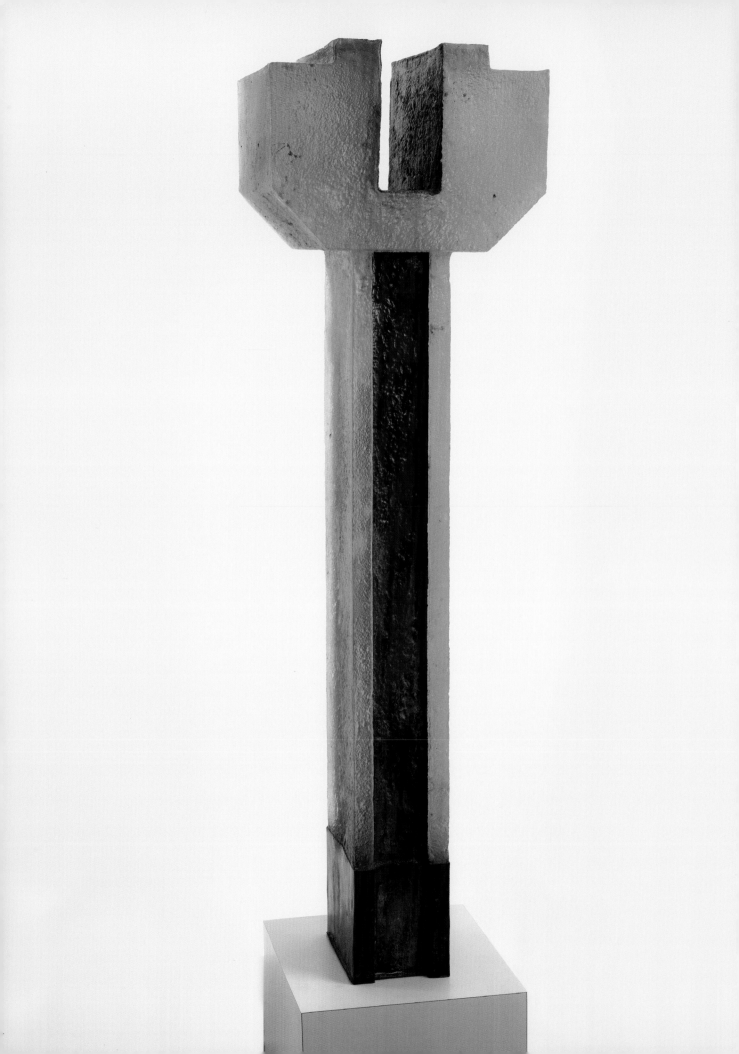

# HOWARD BEN TRÉ

American, born 1949

Howard Ben Tré uses cast glass and metal to create sculptures that embody the human quest for spiritual meaning in a postindustrial world. Like many of his contemporaries in the studio glass movement, Ben Tré came to glass by happenstance. After spending his early twenties as a political activist and becoming disenchanted with activism, Ben Tré returned to college in the mid-1970s in search of a new way to invest his life with purpose.[1] At Portland State University, he studied biology, art history, and studio art, and ultimately decided that making art would be a more personally rewarding and effective way to change the world than overt political activism.[2] Ben Tré saw in sculpture a way to explore his interests in ancient spirituality, architecture, and ritual objects. One day he wandered into the university's glass studio and soon was entranced with this fluid, malleable, and translucent material, perceiving in it sculptural possibilities and numinous qualities.[3] He subsequently studied glass at Pilchuck Glass School in Stanwood, Washington, and earned an MFA in 1980 from the Rhode Island School of Design.

*Structure 30*
1986
cast glass and copper
48 x 14 x 12 inches
(121.9 x 35.6 x 30.5 cm)

Although Ben Tré initially studied glassblowing at Portland State, he stands out among his peers for rejecting that studio-based process in favor of casting glass, an industrial process more akin to that of casting metal for sculpture. The artist begins with gestural drawings, refining them into working drawings made to the scale of the object. He then fabricates Styrofoam molds and sends them to an industrial facility that re-creates the molds in bonded sand for casting hot glass.[4] Ben Tré also uses metal components that are embedded in the glass, wrapped around it, or rubbed on as metal powders. The technological nature of the materials and the process is important to the meaning of the sculptures, serving as a metaphor for our mediated relationship with the industrial objects of our modern-day world.

In the *Structures*, a series resembling architectural fragments, architecture—a discipline that utilizes technology to serve humanistic ideals—symbolizes a dialectic between spirit and matter, ritual and science. With its verticality and its rationalist, bilateral symmetry, *Structure 30* (1986) suggests a weight-bearing element that could have come from either a classical or futuristic structure. Although glass and copper might at first seem like cold, industrial materials, the patina of the copper gives the work an aged, handcrafted look that is complemented by the textural variations and fissures created on the glass by the sand-casting process. The sculpture seems austere and high-tech, yet also serene, ancient, and imbued with inner warmth. Ben Tré has sensitively employed the translucency of glass, its ability to retain light and glow from within, to suggest a spiritual presence. His sculptures have been inspired by religious structures that he has visited around the world, in places such as Mexico, England, and Bali, but they do not directly reference any of these sources. Rather, the abstraction of works such as *Structure 30* gives them an aura of mystery, ineffability, and transcendence, evoking a universal, spiritual quest.

RE

# DALE CHIHULY
American, born 1941

World-renowned for his intensely colored, expressionistic large-scale glass installations, Dale Chihuly is both an integral part of, and apart from, the studio glass movement. Chihuly's first investigations of glass coincided with the origins of studio glass in the 1960s. He began working with it as a student at the University of Washington, Seattle, where he received his bachelor's degree in interior design in 1965. That year, he blew his first bubble from glass that he had melted in a makeshift kiln in his basement.[5] Recognizing his calling, he went on to earn an MS in sculpture in 1967 from Harvey Littleton's graduate program in glass at the University of Wisconsin–Madison, and an MFA in ceramics from the Rhode Island School of Design (RISD) in 1968.[6]

That year, Chihuly received a Fulbright scholarship to study glassmaking at the Venini factory in Murano, Italy, a formative experience that shaped his view of how glass should be made. There, he witnessed the team approach to glassblowing. This traditional, centuries-old approach had been de-emphasized in American studio glass by Harvey Littleton and his acolytes, who believed that it was ill-suited to artistic expression and experimentation. Chihuly disagreed, and, upon returning to the United States, he pursued ways to realize his ideas in collaboration with others. In 1971, he cofounded the Pilchuck Glass School near Seattle, which allowed him to mentor students while also enlisting their help in executing his designs. The team atmosphere not only enabled Chihuly to push techniques further than he could alone, but also became crucial after a 1976 automobile accident cost him his sight in his left eye.

Since then, his role in glassmaking has been more like that of a film director than that of an actor.[7] Chihuly has developed several thematic series to which he has returned continually; of these, the *Seaforms* are perhaps the most recognizable expression of his aesthetic, and they illustrate his mastery of glass as an expressive medium. The shell-like, undulating forms capture the fluidity of glass as it is being blown and the effects of gravity and centrifugal force upon the material. In this example, a rich color scheme of reds, oranges, and yellows, accented with blue, gives the forms a strong visual presence, magnified further by colored shadows that it casts on its surroundings. Nested together, fragile yet seemingly alive with inner energy, the forms vividly evoke the scallops, jellyfish, coral, and other undersea creatures that inspired Chihuly's design. The first *Seaforms* were made in 1980, and this work, created in 1989, reveals the influence of his subsequent series. The color palette has shifted from subtle, pale tones to much brighter ones; the forms include the sort of spots for which his *Macchia*[8] series was named; and the concentric lines are much more pronounced, as they are in the *Persian* series. Chihuly's continuing interest in the *Seaforms* conveys his abiding love of nature as a source of inspiration, and the works themselves successfully embody the beauty of nature within the medium of glass.

RE

*Untitled* from the *Seaform* series
**1989**
blown glass
6 x 13 x 16 inches (15.2 x 33 x 40.6 cm);
5 x 5 x 9 1/2 inches (12.7 x 12.7 x 24.1 cm);
7 1/2 x 6 x 13 inches (19.1 x 15.2 x 33 cm);
7 1/2 x 6 1/2 (19.1 x 16.5 cm);
3 x 3 inches diameter (7.6 x 7.6 cm diameter)

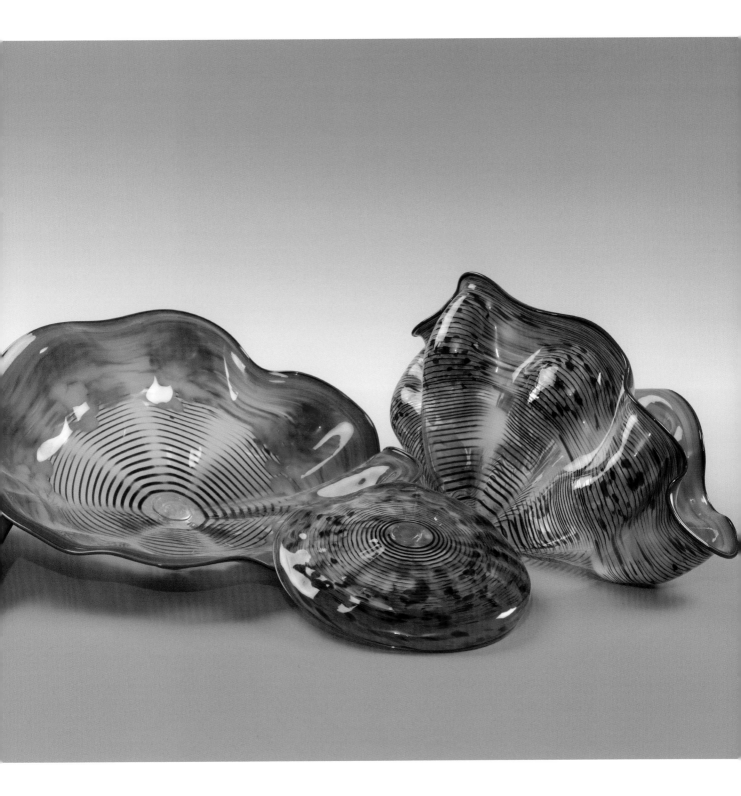

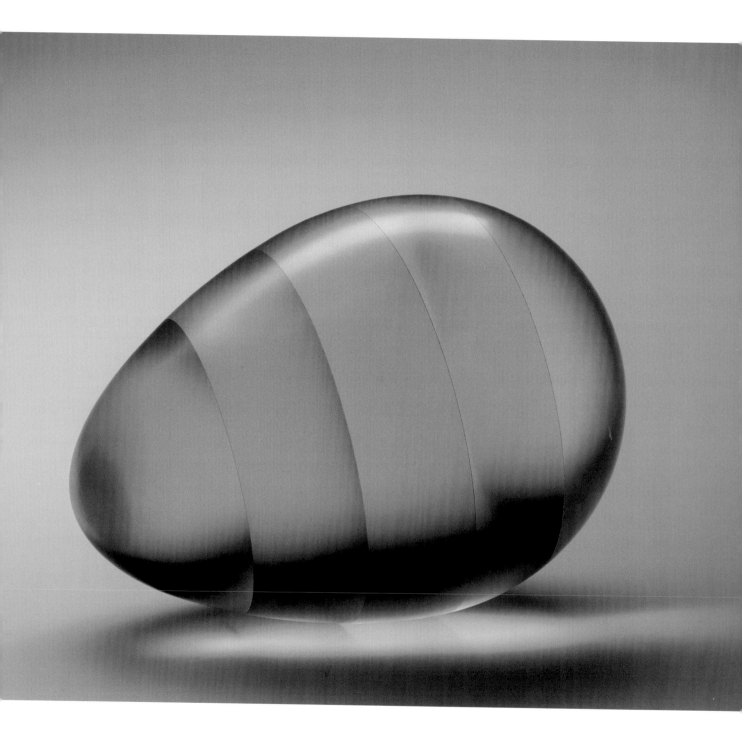

# VÁCLAV CIGLER
Czech, born 1929

Through his teaching as well as through his work, Václav Cigler has helped shape the character of contemporary art in Slovakia and the Czech Republic (formerly known as Czechoslovakia). Encompassing objects, jewelry, lighting, and site-specific installations, Cigler's artistic practice is unified by its focus on the effects of glass on space and the environment. From 1965 to 1979, he led the program in architectural glass at the Academy of Fine Arts in Bratislava, located in present-day Slovakia, and influenced a generation of Czech and Slovak artists to examine the optical qualities of glass.

Cigler's choice of glass as a medium for art is linked with his country's political and economic history. During his formative years as an artist, the Communist government of Czechoslovakia censored art in other media, but supported the country's longstanding glass industry.[9] As a result, much of the country's artistic talent was directed toward glass. Cigler received technical training at the glass school in Nový Bor from 1948 to 1951, followed by additional education at the Academy of Applied Arts in Prague from 1951 to 1957. There, the influential professor Josef Kaplický, a sculptor and painter, advocated a broadminded approach to glass and expected glassworking students to master the fundamentals of art.[10] Cigler's earliest works in glass in the late 1950s were industrially made vases that he cut and engraved with abstract or figural designs.

In the early 1960s, Cigler achieved a breakthrough in his approach to glass that would profoundly affect not only his own work, but also Czech glass more generally. He began to probe the unique ability of glass to both reflect and refract light, and thereby to interact with and alter its environment. Cigler began cutting and polishing glass into geometric objects with concave, convex, and angular surfaces, sometimes laminating together multiple layers within a single piece. At first these objects were made from leaded glass, and later from optical glass. Solid rather than hollow, these objects are pure sculptures that take glass into a metaphysical realm. The distorted reflections created by the play of light on and within their surfaces provoke questions about the relationship of humanity and the natural world, and the inadequacy of the human ability to apprehend reality.

Many of Cigler's later sculptures relate to these concerns; in the 1990s, he created a series of egg-shaped objects, each with different kinds of internal layers. These objects bring to mind a comment that glass artist Marian Karel, who also studied with Kaplický, made about their professor: "He compared abstraction in art to an egg: you had the simple, clean geometric shape on the outside, but it was enlivened by the warm and mysterious life inside of it."[11] This would be an apt description of Cigler's *Untitled* (1990) from the *Egg* series. Its matte finish gives the work a self-contained, quiet, contemplative feel; yet the light passing through its layers activates the object with a radiance that appears to come from within, illustrating Cigler's view of glass as "almost a living organism."[12]

RE

*Untitled* from the *Egg* series
**1990**
cast glass
8 1/2 x 11 1/2 inches
(21.6 x 29.2 cm)

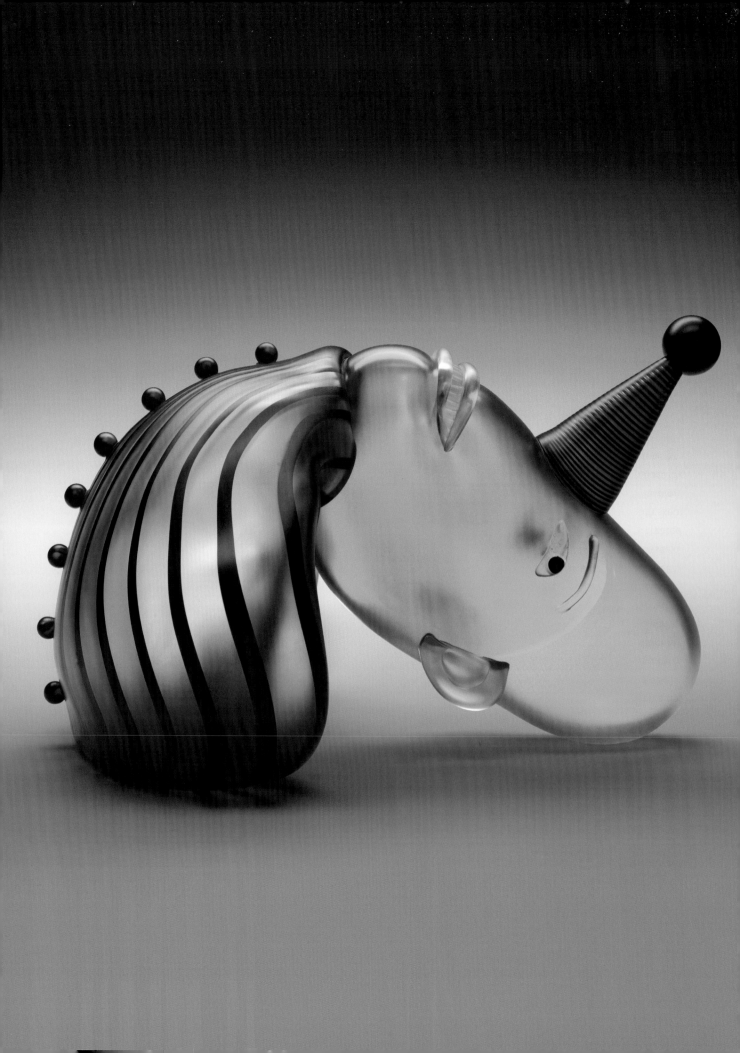

# DAN DAILEY
American, born 1947

Dan Dailey's prolific career as a glass artist began in the mid-1960s, while he was a student at the Philadelphia College of Art. Using ceramics and glass, his early experiments were akin to the pottery of that time. After working briefly as a cartoonist and carpenter in California, Dailey returned to Philadelphia in 1970 to assist the renowned ceramicist William Daley. One year later, he entered Dale Chihuly's master's program in glass at the Rhode Island School of Design. Like Chihuly, Dailey received a Fulbright scholarship to study at the Venini factory in Murano, Italy, after graduation. The experience left him with a positive feeling about the factory environment, so much so that he later collaborated with the Daum factory in Nancy, France, as well as with Steuben, Waterford, and others. Since 1973, in addition to maintaining his studio practice, Dailey has taught glass at the Massachusetts College of Art in Boston in a program that he founded.

*Fool* from the *Individuals* series
**2004**
blown glass
12 1/2 x 14 x 19 inches
(31.8 x 36.8 x 48.3 cm)

Drawing lies at the heart of Dailey's glass production, and it is an essential step in his creative process. He has filled numerous sketchbooks with drawings, many of which have been translated into glass objects. Dailey recently remarked that "the sketchbook provides total freedom. But drawing also clarifies and codifies my thinking."[13] His subject matter often conveys the emotions associated with the human condition. Whether comic, sad, or poignant, his drawings and glass capture his assessment of society in all its glory and ignominy.

Dailey most often works in series. His earliest pieces are blown-glass vases with stylized imagery of heads, wildlife, people, and scenes from America. Although not overtly narrative, these motifs, along with the emotions mentioned above, hint at the subject matter that would become the focus of his mature work.

In 1982, Dailey began a series of Vitrolite wall-relief panels that rely on the figure and storytelling. Vitrolite is a structural glass product made by Libby-Owens-Ford Company that had gained popularity in the 1910s through the 1930s as an efficient way to introduce graphic color into the interiors and facades of commercial buildings and private homes. Dailey discovered the material in 1970 at an old glass shop in Bristol, Rhode Island.[14] For the next ten years, he contacted glass shops across America, searching for any remaining Vitrolite, and assembled a vast collection of it in a wide range of colors.[15] Vitrolite was the perfect material for Dailey to use in the wall panels because it could be cut and polished, and its surface could be engraved or painted. To create the wall reliefs, he begins with drawings, making a full-scale rendering to serve as a template for the assembly of the individually cut pieces of Vitrolite. He then arranges the composition of glass, cuts metal to fit over or into the glass matrix, and affixes the entire work to an aluminum panel.[16]

Most of Dailey's Vitrolite panels are wholly figural in their subject matter, yet in a few, such as *View of Lust* (1983), the figures play a secondary role. According to the artist, this work's narrative was inspired by the life of Benvenuto Cellini, the sixteenth-century Italian artist who was renowned for his womanizing.[17] Here, Dailey references the artist's love of chasing women, but the figures are only partially revealed through the grand architecture of an unspecified palace.

The curator and critic William Warmus recently compared Dailey's Vitrolite wall reliefs to ancient Egyptian hieroglyphic images.[18] Dailey has long been interested in Egyptian art. He is inspired by the articulated designs of the low-relief, figural, mosaic wall-art found in the pharaohs' tombs, as well as the richness of the color palette used to create them.[19] His wall reliefs are linked to the portrayals of ancient Egyptian life though their stylized nature, which also brings to mind Art Deco designs of the Jazz Age.

Dailey continued using figural images in his vases, heads, and lamps throughout the 1980s and 1990s. In 2004, he began a new series of portraits called *Individuals*. Unlike his previous figural works, the majority of these pieces take the form of traditional sculptural busts. Each character vibrantly illustrates the attributes associated with its title. For *Fool* (2004), Dailey abstracted a human form with its head thrown back to suggest a larger-than-life attention-seeker who strives to be noticed. He has created a wistful portrayal imbued with both skepticism and sympathy. In his typical fashion, Dailey has turned the mirror to reflect the underside of humanity, bringing to light emotions and experiences that are often left unaddressed.

CS

*View of Lust*
1983
Vitrolite and blown glass
28 x 35 1/2 inches
(71.1 x 90.2 cm)

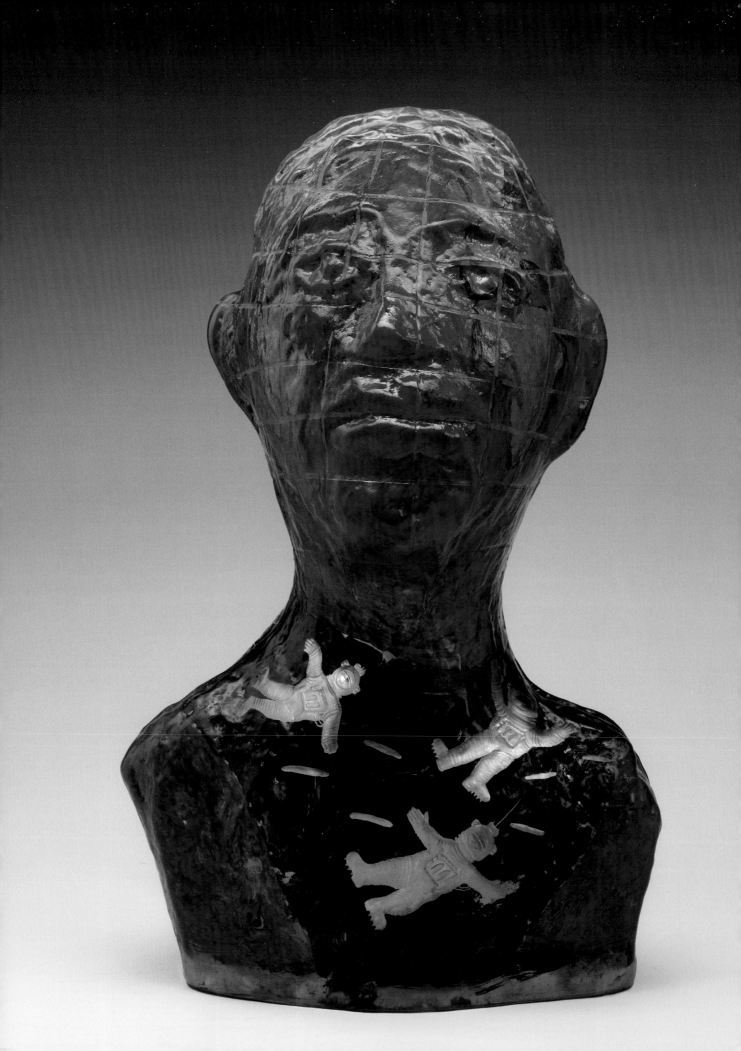

# ERWIN EISCH
German, born 1927

As the descendent of two generations of Bavarian glass engravers, Erwin Eisch taught himself to engrave in his father's studio before enrolling in design at the Akademie der Bildenden Künste in Munich in 1949. Discouraged by the academy's advocation of Bauhaus purity in glass, which denied the decorative aspects of engraving,[20] Eisch returned to his family's factory in 1952. During this time, he began to experiment with hot glass. In 1956, he returned to the academy to study painting and sculpture, finding these pursuits much more in line with his aesthetic sensibilities.[21]

Upon the completion of his studies in the early 1960s, Eisch continued to take a liberated approach to sculpture and painting, employing the techniques of his native material. A product of this approach caught the eye of Harvey Littleton, who was on a research visit to Europe in August of 1962. Eisch and Littleton formed a friendship that would influence the development of studio glass the world over. At Littleton's invitation, Eisch traveled to the United States for the first time in 1964 to participate in the World Congress of Craftsmen in New York and to give a demonstration at Littleton's program at the University of Wisconsin–Madison.[22] Since that time, Eisch has cemented his role as the "Spiritual Father of Studio Glass"[23] in Europe and in the United States through lectures, workshops, and classes.

*Globeman with Astronauts*
**1999**
mold-blown glass
18 x 12 x 7 inches
(45.7 x 30.5 x 17.8 cm)

Eisch's works reject the inherent properties of the material, its optics, transparency, and shine, and instead use glass as a "hanger"[24] for illustrated conceptual ideas. Eisch subverts the traditionally industrial process of mold blowing to create Pop Art-associated objects that explore the alienation of the individual in the face of globalization and promote the hand of the maker as an alternative to industrialization.[25] *Globeman with Astronauts* (1999) furthers Eisch's investigations into symbolic portraiture. Whereas his earlier busts depict the recognizable features of Littleton, Pablo Picasso, Buddha, or German Chancellor Helmut Kohl to make statements about the nature of the individual in society, *Globeman* has indeterminate features; his individuality is obscured by his "global consciousness." The mantle of outer space that he wears across his shoulders gives him a sense of isolation, separated from society by the vacuum of space.

Ever since his earliest reactions against Bauhaus philosophy, Eisch has made objects that have engaged in a critical dialogue with globalized culture and industrialization. But his work is perhaps best seen through the lens of the Situationist Gruppe SPUR, which he joined in 1958. Promoting a revitalization of European culture "through the renewal of individualism" rather than through "collective thought,"[26] and opposing a narrowly defined idea of truth, the group's manifesto of 1958 states: "Art relies upon instinct, upon primary creative forces. To the detriment of all intellectual speculators, these free, wild forces always push toward the appearance of new, unexpected forms."[27] Eisch brought that instinct and those "wild forces" to the development of studio glass in order to shake it free from its industrial uses.

SJS

## FUJITA KYOHEI
Japanese, 1921–2004

Fujita Kyohei[28] was a pioneer of studio glass in Japan, a country that previously had perhaps the weakest tradition of glassmaking of any country that produced studio-glass artists. He graduated from the Tokyo School of Fine Art in 1944 with a degree in metalworking, but later was drawn to glass when he saw Persian glass objects in an exhibition of the Shōsōin Imperial Collection. In 1949, he set up a studio where he taught himself glassblowing and other glassworking techniques. Eight years later, he had his first solo exhibition of hand-made functional glass at Ueno Matsuzakaya, a department store in Tokyo—one of the few venues in which glass artists could exhibit in Japan at the time. At other such exhibitions throughout the 1960s, Fujita gradually intro-duced more sculptures along with functional objects.[29] He helped to change Japanese attitudes toward the possible uses of glass, partly because he made objects suitable for use in the Japanese tea ceremony.[30]

As Fujita's skills increased, so did recognition of his work; by the early 1970s, as the medium of glass grew in popularity among artists in Japan as elsewhere, Fujita emerged as a leader in the field. In 1972, he cofounded the Japan Glass Artcrafts Association and served as its president from 1976 almost continuously until his death in 2004. The organization promotes the art of glass through exhibitions, lectures by international artists and curators, and a permanent gallery space.[31] Fujita received his first recognition abroad when he was included in the *International Studio Glass* exhibition and conference in Copenhagen, Denmark, in 1975. He exhibited *Iris*, a covered glass box inspired by Japanese lacquer boxes, which was praised as a distinctively Japanese response to the medium of glass. Fujita's series of glass soon became his best-known work.

In Copenhagen, Fujita met other glass artists and effectively became an ambassador for Japanese studio glass worldwide, frequently representing Japan at World Crafts Council conferences.

With the glass boxes, Fujita sought to imbue glass with the rich traditions of Japanese art. Mold-blown with inclusions of gold, silver, and platinum leaf, they reference not only lacquer boxes, but also other traditional Japanese crafts, such as the rich colors and patterns of textiles and handmade paper. The boxes have evocative titles that relate their abstract designs to nature or to aspects of Japanese culture—subject matter also depicted in Rimpa paintings, a style fashion-able in eighteenth-century Japan that inspired Fujita.[32] *Taketori Tale* refers to a late-ninth or early tenth-century fairy tale about a princess who comes from the moon and is found in a stalk of bamboo as a baby. When she reaches adulthood, the princess must return to the moon, but before disappearing, she writes a letter to the emperor, one of her suitors. He burns the letter atop Mount Fuji, the highest mountain in the land, and the smoke miracu-lously continues to rise forever.[33] Fujita's *Taketori Tale* box of 2000 beautifully evokes the bamboo, the moon, and the smoke in its color scheme of green, gold, and silver.

RE

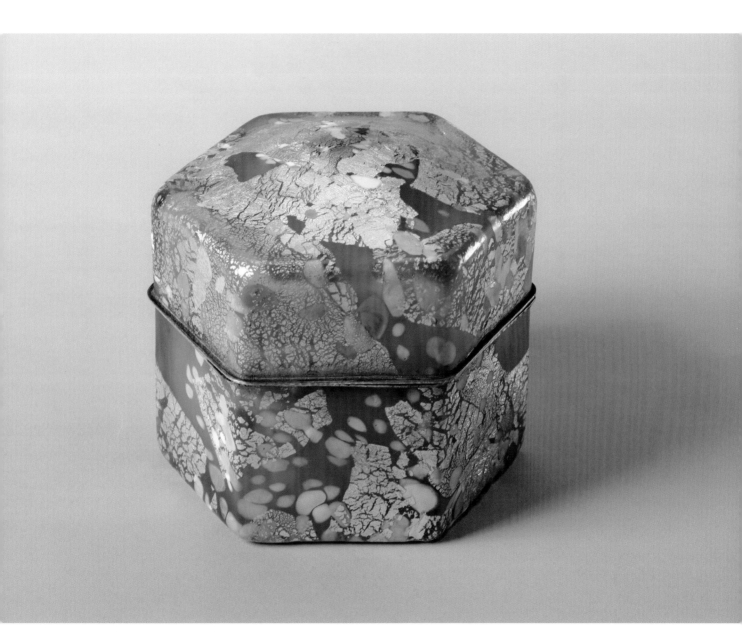

*Taketori Tale*
**2000**
blown glass, gold, and silver
4 1/8 x 4 1/2 x 4 1/8 inches
(10.5 x 11.4 x 10.5 cm)

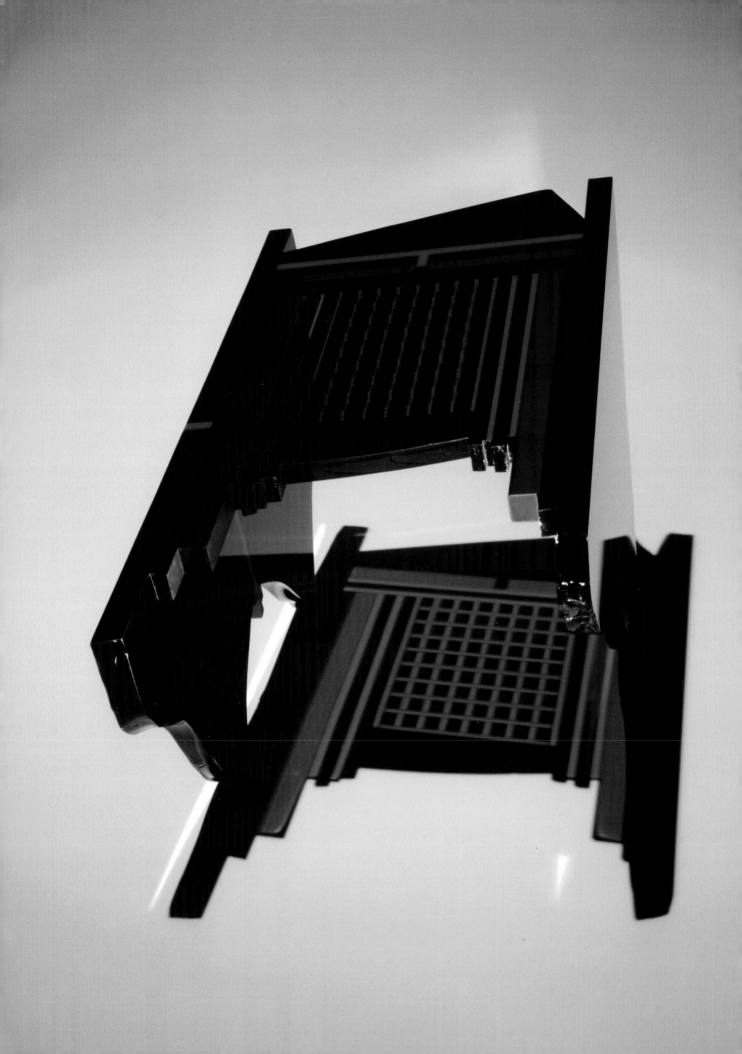

# DAVID HUCHTHAUSEN
American, born 1951

David Huchthausen found an abandoned glass furnace while studying sculpture at the University of Wisconsin–Wausau in 1970, and spent several months working with glass in relative isolation.[34] After receiving his associate's degree, he transferred to the University of Wisconsin–Madison, where he enrolled in Harvey Littleton's glass program and soon became his assistant. Huchthausen earned a BS degree in 1975, and the following year joined Joel Philip Myers's graduate program at Illinois State University in Bloomington–Normal, eventually graduating with an MFA in 1977.[35] While in school, Huchthausen experimented with both glass-blowing and flat-glass laminating techniques, though his first commercially successful work was a series of multilayered "fantasy" vessels. Stylized, abstracted, and opaque, these pieces present a highly abstracted view of images drawn from nature.

Huchthausen was awarded a Fulbright-Hays scholarship to the University of Applied Arts in Vienna, Austria, in 1978. Limited by the facilities while abroad, he used this opportunity to push the "fantasy vessels" to their technical limit, concluding his involvement with blown glass.[36] Returning to the United States in 1978, Huchthausen worked as a designer at Milropa Studios in New York before becoming the first director of glass programs at the Appalachian Center for Craft, Tennessee Tech University, where he stayed from 1980 to 1989.[37]

During this period, Huchthausen began re-exploring laminated, flat glass as a means to express his interest in architecture, archaeology, and artifacts, which led to his groundbreaking series Leitungs Scherben in the early 1980s. The Leitungs Scherben, whose name, roughly translated, means, "fragments of transmission,"[38] juxtapose the high-tech with the primitive, balancing a highly polished grid of laminated glass and Vitrolite atop fragmented, uneven supports. The transmission of light to the surrounding area, shown to great effect in LS83G (1983), is perhaps the most distinctive aspect of this work. Produced at a scale that at once calls to mind the intimacy of artifact and the monumentality of architecture,[39] the Leitungs Scherben appear to be miniature site-specific installations—making illusory and transitory adjustments to the very space they define.

Just as Huchthausen revolutionized his own work with the Leitungs Scherben, so too would he influence the thought processes of the larger studio glass movement. In the late 1970s and early 1980s, Huchthausen served as a consultant to the Americans in Glass triennial, a series of international exhibitions originating at the Leigh Yawkey Woodson Art Museum in Wausau, Wisconsin. Evidenced in his catalogue essays for each of the three shows and in his curatorial decisions was Huchthausen's desire to broaden the field to include "mainstream" artists working in glass and critical theory.[40] He highlighted the studio glass movement's insular nature and obsession with technique and countered that, in order to achieve artistic relevance and acceptance, the work must support personal concepts.[41] Though much of his call for increased critical analysis and intellectual rigor has gone unheeded, Huchthausen's early vocalization of these needs, combined with his years as a teacher and the continued mastery of his objects, has immortalized his visionary role in the development of studio glass.

SJS

*LS83G* from the
*Leitungs Scherben* series
1983
glass and Vitrolite
12 x 10 x 19 inches
(30.5 x 25.4 x 48.3 cm)

## STANISLAV LIBENSKÝ
Czech, 1921–2002

## JAROSLAVA BRYCHTOVÁ
Czech, born 1924

Through their architectural works, site-specific commissions, and sculptures, Stanislav Libenský and Jaroslava Brychtová explored the physical properties of cast glass for almost fifty years. As teachers, colleagues, and artists, they have been revered, particularly for their technical innovations in cast glass.

While enrolled at Prague's Academy of Applied Arts, Libenský studied with the legendary sculptor and glass artist Josef Kaplický, while Brychtová was taught by Karel Štipl. By the mid-1950s, Libenský was working in Železný Brod at the Specialized School for Glassmaking, and Brychtová had founded the Department of Architectural Glass in the same town. They began collaborating on cast-glass sculptures about 1954, with Libenský drawing formal designs and Brychtová translating them into full-size clay models and reproducing them in plaster, from which a mold could then be made for the casting of glass. Throughout the first decades of their careers, in addition to making their own work, they maintained positions within the teaching community. Libenský was headmaster at a secondary school for glassmaking at Železný Brod from 1954 to 1963 and department head at the Academy of Applied Arts in Prague from 1963 to 1987, while Brychtová worked in the Department of Architectural Glass until 1984.

Cubism, Surrealism, the sculptures of Constantin Brancusi, and the ethnographic materials of Africa and Oceania were among their early and ongoing influences.[42] By combining these interests with Czech historical and folk traditions, Libenský and Brychtová developed their own distinctive aesthetic in which figurative imagery, texture, and saturated color played prominent roles. Yet in the late 1960s, they abandoned color and relied instead on optical effects to provide illumination and depth in their sculpture. They also began making smaller works that were often preliminary experiments for large architectural glass installations.

In the 1980s, Libenský and Brychtová began to travel internationally on a regular basis to participate in exhibitions, symposia, and workshops, receiving acclaim for their glass and becoming an integral part of the larger glass community. Their technique also evolved; they ceased grinding the edges of their sculptures to make them smooth, instead opting for the irregular edges caused by the overflowing glass as it seeped through fractures in the mold. In 1986, they built a studio in Železný Brod, where they initiated numerous series of glass sculptures that are regarded as their most expressive and intimate.

The *Space* series, from which this work, *Spaces VI* (1995), comes, exemplifies this new direction in artists' glass. With its translucent surface and central void, the sculpture uses light to define its spatial planes. Depending on the location and intensity of the light source, the color and tone of the sculpture mutate, subtly changing from gray to purple. The critic Robert Kehlmann appropriately summed up the intellectual and emotional power of the *Space* pieces by asking: "Can Libenský and Brychtová be suggesting that the passage to freedom, and light, is not always direct or obvious? That perhaps, at times, we may see or feel the force of life's inner glow within ourselves, yet its source is veiled from our immediate vision by the material world?"[43]

CS

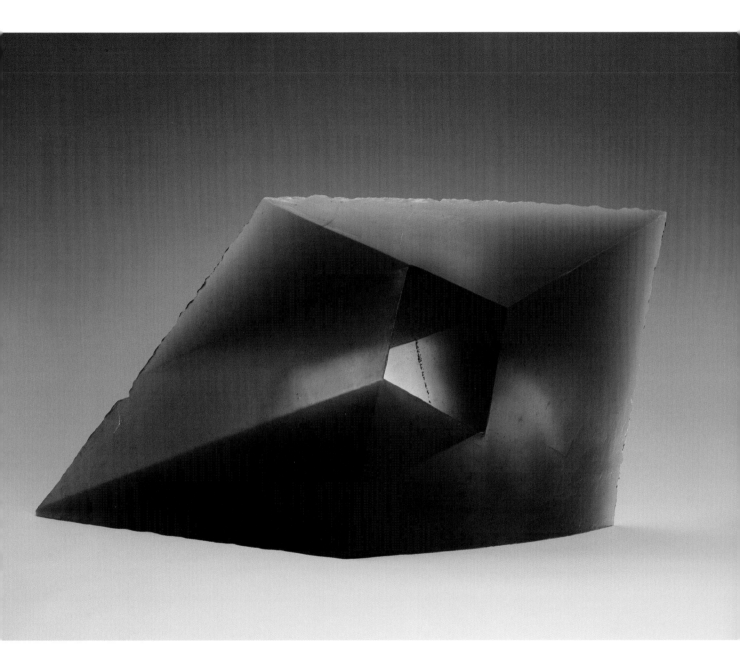

*Spaces VI*
**1995**
cast glass
20 x 41 x 9 1/4 inches
(50.8 x 104.1 x 23.5 cm)

## MARVIN LIPOFSKY
American, born 1938

Marvin Lipofsky received a degree in industrial design from the University of Illinois in 1962. In the fall of 1963, he enrolled as a graduate student in ceramic sculpture at the University of Wisconsin–Madison.[44] His first class was with Harvey Littleton, who had just completed the Toledo Workshops, launching the studio glass movement. Littleton encouraged his students to explore this material in new ways, and Lipofsky was soon won over.

In 1964, Lipofsky accepted a position as the second glass professor in the United States at the University of California, Berkeley.[45] Three years later, he started another program at the California College of Arts and Crafts in Oakland, where he taught until 1987. In 1968, Lipofsky initiated the Great California Glass Symposium to encourage the exchange, development, and knowledge of glass in the region. In the symposium's twenty-year existence, more than one hundred national and international artists and designers traveled to Berkeley and Oakland to give demonstrations, workshops, and lectures.[46]

This spirit of exchange has been integral to Lipofsky's career and artistic output. Since 1970, he has worked and taught in more than twenty-five countries. On one early trip to the Nuutajärvi Glass Factory in Finland, Lipofsky watched the traditional factory technique of mold blowing. He observed a small amount of glass balloon above the mold, creating a sensuous, bulbous shape. In an attempt to harness, celebrate, and explore this by-product of industrial process, Lipofsky arranged old wood molds on the floor, instructing the gaffers to fill the newly created form.[47] Through further manipulation with handmade wooden tools, he embarked upon a process that would be integral to his work for years to come.

Once annealed, the blown forms are shipped back to Lipofsky's studio in Berkeley, where they are sandblasted, carved, and polished.[48]

Each of his series is named for the location in which it was made; each piece, through color and shape, attempts to harness the atmosphere of the place.[49] At the invitation of Professor Stephen Rolfe Powell, Lipofsky created *Kentucky Series #8* with the students of Centre College in Danville, Kentucky, in 2000–2001. One can see elements of Powell's richly hued objects as well as brilliant flashes of the racing silks of the Kentucky Derby.[50] Cloudlike, translucent, and enigmatic, this piece highlights the particular ability of glass to exist between states—molten and frozen, soft and brittle, transparent and opaque—to call to mind the ethereality of memory and moment.

Lipofsky transforms age-old processes and techniques of glassblowing into the stuff of creative production. He has altered the perception of the material by bringing it from the factory into the world of art, but he has also brought art into the factory. Rather than breaking with tradition, he has negotiated, inverted, and altered traditional practices to demonstrate that the factory, too, can be a fertile location for the production of creative works, transforming the way multitudes of glassworkers perceive the possibilities of their material.

SJS

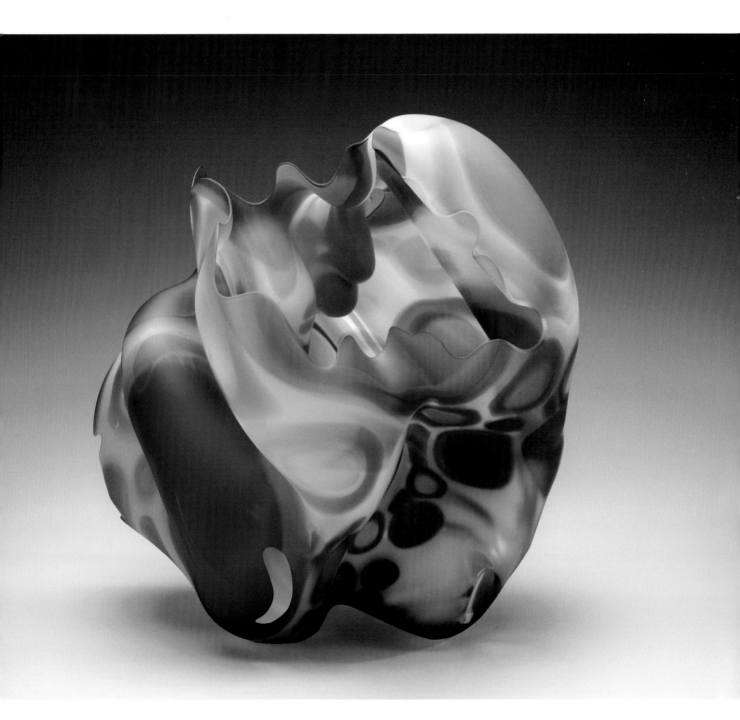

*Kentucky Series #8*
**2000–2001**
blown glass
16 x 17 x 17 inches
(40.6 x 43.2 x 43.2 cm)

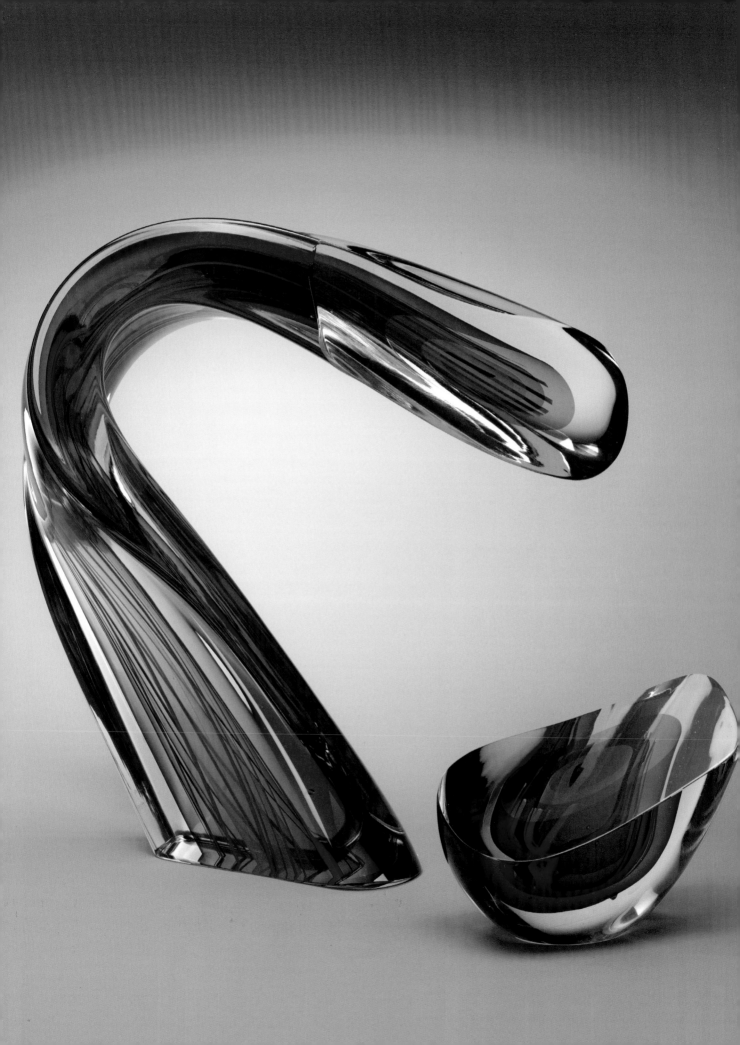

# HARVEY LITTLETON
American, born 1922

Harvey Littleton is known as the "Father of Studio Glass." The son of a prominent glass scientist, and raised in the "glass city" of Corning, New York, Littleton first experienced glass as a child through his father's work.[51] He initially studied physics at the University of Michigan in Ann Arbor, but ultimately graduated with a bachelor of design degree. Later, he received his MFA from the Cranbrook Academy of Art in Bloomfield Hills, Michigan, where he studied with Finnish ceramicist Maija Grotell.[52]

In 1951, Littleton joined the faculty of the University of Wisconsin–Madison in the Ceramics Department.[53] He had previously dabbled in glassworking, but a research trip to Europe in the late 1950s ignited his passion for the material. There he met French proto–studio-glass artist Jean Sala, whose plans for a small studio-glass furnace inspired Littleton to believe that glass could be made by individuals outside of a factory.[54] In 1959, Littleton reported his experiences at the American Craft Council conference in Lake George, New York, and was encouraged to make glass a material of the studio artist.[55]

*Red/Blue C Form*
**1989**
blown glass
12 1/2 x 12 x 4 inches
(31.8 x 30.5 x 10.2 cm);
2 1/2 x 6 1/4 x 3 inches
(6.4 x 15 .9 x 7.6 cm)

By 1962, Littleton had gathered sufficient information to conduct the now-famous Toledo Workshops. These two workshops, held in March and June of 1962 on the grounds of the Toledo Museum of Art, Ohio, are widely considered to be the birth of the studio glass movement. With the support of the museum and the technical knowledge of Dominick Labino, director of research at Johns-Manville Fiber Glass Corporation, and retired industrial glassblower Harvey Leafgreen, participants melted and blew glass on a small scale for the first time in the United States.[56]

Following the success of these workshops, Littleton returned to Europe, where a chance encounter introduced him to the Bavarian artist Erwin Eisch. Eisch's liberated and non-traditional approach to the material cemented Littleton's commitment to making glass a material of creative expression, rather than utility.[57] In the fall of 1962, Littleton returned to the University of Wisconsin and established the first university glass program in the country.[58] His drive and dedication inspired his students and helped expand the use of the medium. Today, almost all American studio-glass artists can trace their lineage to Littleton or to one of his students.[59]

In 1977, Littleton retired from teaching to pursue his studio work full-time. In the following fourteen years, until he stopped working in hot glass in 1991, he produced some of his most well-developed sculptural series.[60] In *Red/Blue C Form* (1989), a mass of hot glass is frozen in a moment of fluid movement, preserving the viscous richness of the material as it stretches and bends under its own weight. One's eye is drawn along the length of the arc by thinly veiled color separated by successive layers of crystal and punctuated by bright canes. The cut and polished ends reveal the concentricity inherent to hot-worked glass in delicate rings of color. *Red/Blue C Form* masterfully achieves Littleton's desire to see glass as a medium for sculptural expression while magnifying the material's particular qualities.

SJS

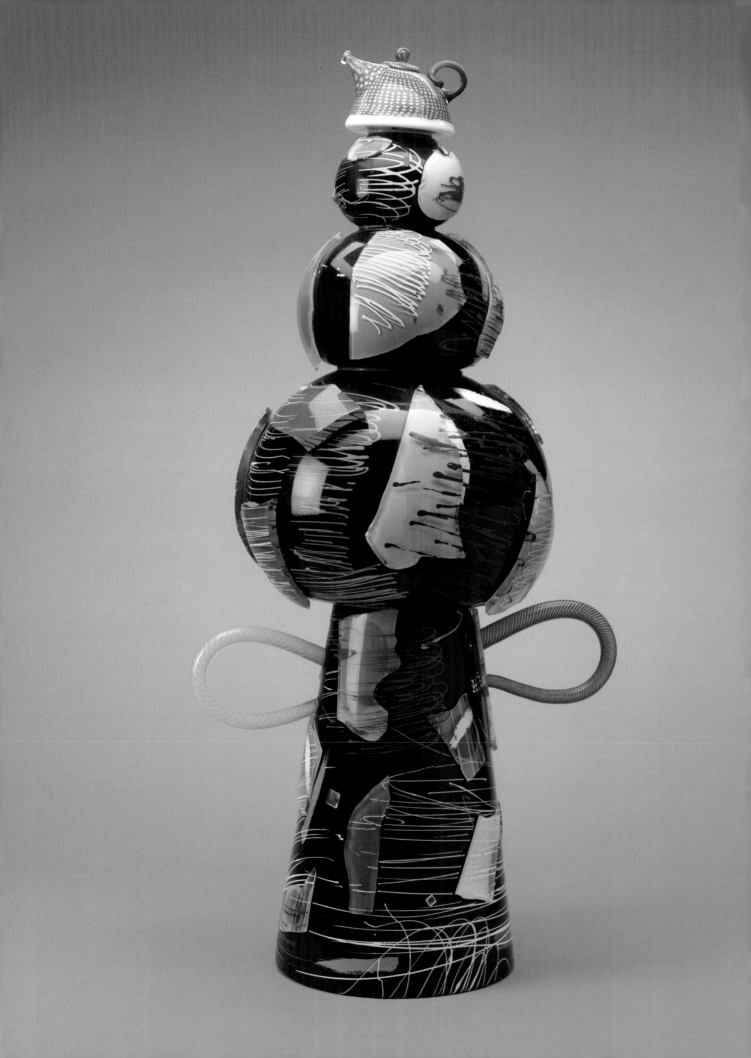

# RICHARD MARQUIS
American, born 1945

An inveterate collector of offbeat cultural objects and a glass historian, Richard Marquis is also a prolific glass artist who has created a masterful body of work over his five decades in the field. Marquis came of age as an artist during the heady, experimental years of the 1960s. He enrolled at the University of California, Berkeley, in 1963 to study architecture, but soon became enamored of the decorative-arts department, especially the ceramics courses taught by the legendary artists Peter Voulkos and Ron Nagle. Voulkos championed the nonfunctional abstract sculptures that he had begun at the Otis Art Institute in the late 1950s, while Nagle was a leading practitioner of the West Coast "fetish-finish" style, which prioritized color and sleek surfaces. The hotbed of creativity in California also introduced Marquis to the "funk" sensibility and ceramics of Robert Arneson and David Gilhooly, who taught at the University of California, Davis. Marquis's early ceramics were particularly indebted to funk, yet they also reflected Nagle's aesthetic, as well as the conceptual work of Jim Melchert, who taught sculpture at Berkeley during this period. The paintings of Giorgio Morandi, the comic illustrations of Robert Crumb, and the assemblages of H. C. Westermann and Joseph Cornell have also been cited as early influences on his aesthetic.[61]

Marquis was first introduced to glass in 1964 when Marvin Lipofsky arrived at Berkeley to establish a glass program. Marquis became Lipofsky's teaching assistant, but because there was little time to develop skills during classes, he built his own glass studio in 1967 to practice blowing techniques. From this

point to the early 1970s, he worked in both ceramics and glass, though his glass shapes, like those of many of his contemporaries, were most often derived from ceramic forms.

During this time, Marquis undertook extensive research into the historical use of glass— early American and ancient Roman glass in particular. In 1969, he continued this research through a Fulbright-Hays grant to Murano, Italy. There, he worked at the legendary Venini factory as a guest designer. Marquis, unlike previous foreign visitors to the factory, wanted to work on the factory floor, where he could observe the master glassworkers, known as *maestros*, and learn skills, rather than simply produce designs for fabrication. Of his time at Venini, Marquis has remarked, "The experience looms large in my development as an artist and as a person. It was a generous and amazing opportunity . . . at the time I received the Fulbright grant to go to Italy, I was considered one of the most skilled [American] glassblowers in the fledgling studio glass movement. It was a pitiful state of affairs. I was about as skilled as a ten-year-old on Murano."[62]

At Venini, Marquis was struck by their use of color, which was not yet popular in American glass, as well as by the development and use of *murrine*, floral- or geometric-patterned elements made by fusing multicolored rods of glass. He would make the *murrine* technique his own, ultimately teaching it to students throughout the United States upon his return in 1970.

*Bubbleboy NZ5*
1988
blown glass and paint
27 x 13 1/2 x 10 inches
(68.6 x 34.3 x 25.4 cm)

*Murrine* became a signature motif for Marquis, and he employed it in a wide range of shapes. Contemporary glass historian Susanne Frantz has remarked that "his work has continued to grow and become more and more interesting while still rotating around this central theme which . . . is a technique."[63] Marquis defined his aesthetic rationale, stating: "There's a vast background vocabulary of revered historical images, techniques, and decorations. By using these in combination with lowbrow objects and intentionally sloppy or loose techniques, I'm able to question and re-examine traditional aspects of working with glass. What some see as my irreverence toward glass, I see as a good balance of form, color . . . [and] decoration."[64]

Marquis spent the 1970s and early 1980s teaching glass at the university level, running a production business, and maintaining his own studio. His glass from the period comprises a series of *murrine* teapots. His *Animated Sculptures* soon followed, as did a series of installations and individual works that feature found objects or pieces from the artist's growing collections. In the mid-1980s, he developed a new signature style, seen in the *Trophy* and *Shard Rocket* series, that combined stacked elements, glass shards, painterly graffiti, found objects, historical glass, and consumer products, and featured handles embellished with *zanfirico* (filigree). From the late 1980s to the mid-1990s, Marquis borrowed elements from

*Oil Can #7*
**1993**
blown glass and found objects
51 1/2 x 21 1/2 inches diameter
(130.8 x 54.6 cm diameter)

these series to create the *Bubbleboy* and *Oil Can* works, represented here by *Bubbleboy NZ5* (1988) and *Oil Can #7* (1993).

About 1990, Marquis began his most famous series, the *Marquiscarpas*. Named by the Italian glass artist Lino Tagliapietra, the series pays homage to the mosaic and *murrine* glass designed by Carlo Scarpa, one of the most important glass designers to have ever worked in Murano. In 1934, Scarpa was made design director of the Venini factory; he remained there until 1947. Marquis has said that the *Marquiscarpas* "are the result of my wonder and admiration of [ancient] Roman work and Carlo Scarpa's designs for Venini before World War II. I made [the *Marquiscarpas*] because I pay attention to history. I made them because I wanted to see how I would make them. I made them because to me it was the obvious thing to do."[65]

Marquis based his canoe-shaped or shallow dish-shaped forms on a range of historic models, including European chalices, Asian, African, and ancient Egyptian headrests, and ancient Greek drinking cups. He fabricates them in stages, first arranging and fusing the *murrines* for the dish and slumping them over a mold, then blowing the knop and columnar base, and finally assembling the composition. Often he inserts personal references into his *Marquiscarpas*. In *Marquiscarpa #11* (1991), he has scattered five *murrines*, including one that spells out "Marquis," a stars-and-stripes motif that refers to his *American Flag* series, and three geometric designs that may refer to his individual collections. The addition of these elements adds a touch of narrative whimsy to the overall composition, a device often seen in Marquis's engaging glass sculptures.

CS

*Marquiscarpa #11*
**1991**
glass
6 x 8 x 4 3/4 inches
(15.2 x 20.3 x 12.1 cm)

## KLAUS MOJE
German, born 1936

Trained in glassworking in Germany's apprenticeship tradition, Klaus Moje transitioned into the world of studio glass in the mid-1970s and gained international recognition for his use of fused glass to create intensely colored, optically energized, sculptural vessels. Moje apprenticed in his father's glass-cutting workshop as a teenager, then gained additional technical training at glass schools in Rheinbach and Hadamar, Germany.[66] Subsequently, he went into business executing stained-glass commissions and creating cut-glass vessels.[67] He also entered the international crafts scene, representing Germany at the World Crafts Council in 1969, and learned of the burgeoning studio glass movement. In 1973, he and his then-wife and fellow glass artisan, Isgard Moje-Wohlgemuth, opened a gallery in Hamburg that exhibited such artists as Erwin Eisch, Ann Wolff, Dale Chihuly, and William Morris.[68]

In the early 1970s, Moje had an experience with glass that forever changed his direction: while shopping for supplies at a German manufacturer, he saw colored glass rods used for making buttons and jewelry. Intrigued, he began experimenting with them, cutting them into small pieces with diamond-cutting tools, arranging them into geometric patterns, and fusing and molding them in a kiln to form vessels. Remarkably, Moje had rediscovered the mosaic technique, used in Roman times and since lost. This technique so fascinated him that it has been the focus of his work in glass ever since. Moje exhibited his mosaic vessels to great acclaim, and his career as a studio-glass artist was born.

His mastery of kiln-fusing was such that in 1979, at the invitation of Dale Chihuly, Moje taught a workshop at the Pilchuck Glass School. Soon he was fielding offers to become a permanent faculty member at universities in the United States and elsewhere. Although Moje rejected several of these offers, an invitation to establish an entirely new program in studio glass at the Canberra School of Art in Australia proved impossible to resist. From 1982 to 1991, Moje built a successful glass program there, mentoring some of Australia's most talented artists and securing a central place for Canberra in the international arena of studio glass.[69]

Moje's move to Australia proved another defining moment for his work. The searing, vivid colors of Australia's landscape crystallized Moje's existing interest in color juxtapositions, while the challenges of teaching motivated him to push his technical skills even further to create more complex geometric compositions. Works like *Untitled*, from 1989, reflect the results of these endeavors. Here, Moje has created a sophisticated interplay of pattern, color, and form. Triangular sections with lines of cool blue intersect gridded areas in which black and white herringbone-patterned squares alternate with multicolored ones that swirl kaleidoscopically, nearly obliterating the grid. Two compositional principles exist in tension: the rational order implied by the gridded and linear areas, and the entropy suggested by the tempestuous swirls of color. This tension activates the work with an internal energy that is further enhanced by the luminosity of glass.

RE

*Untitled*
**1989**
fused glass
10 1/4 x 10 1/4 x 2 1/2 inches
(26 x 26 x 6.4 cm)

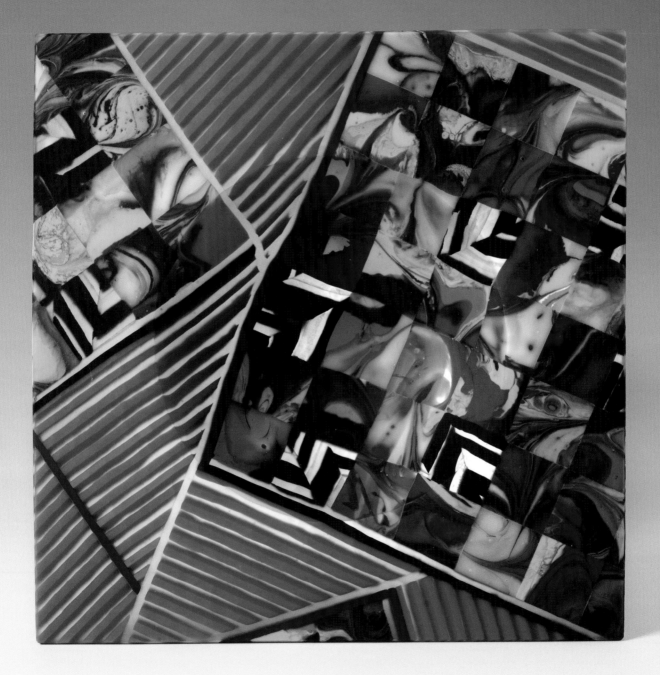

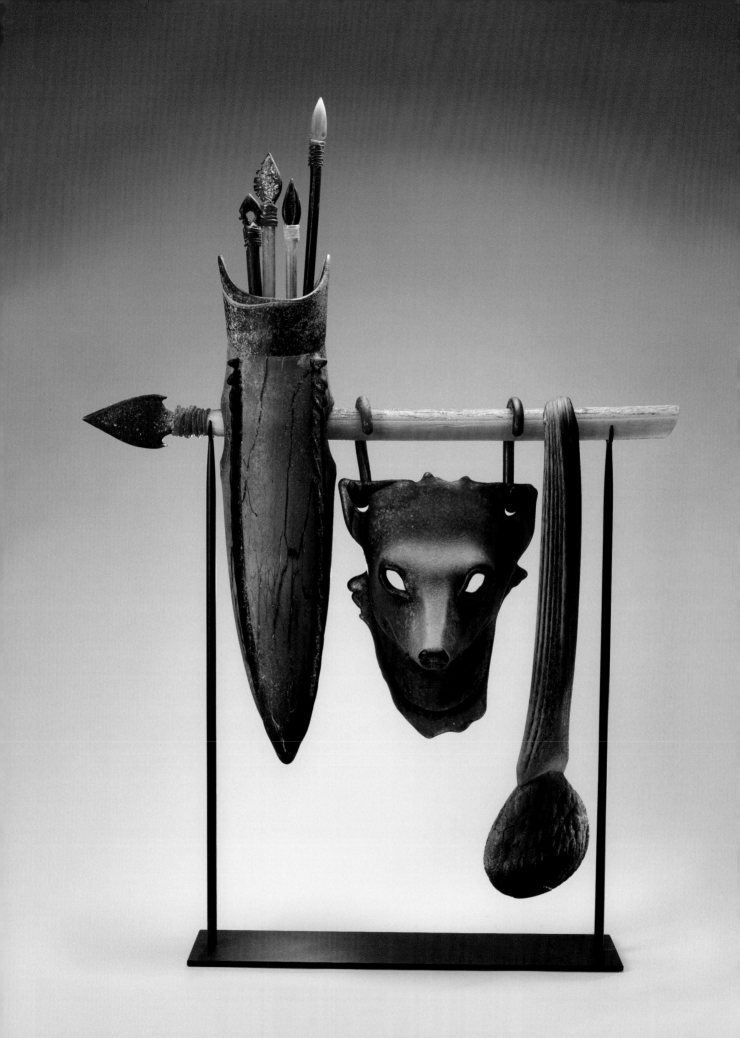

# WILLIAM MORRIS
American, born 1957

Like many of his contemporaries, William Morris came to glass through ceramics, which he had studied at California State University, Chico, and Central Washington University. In 1977, he joined the newly established Pilchuck Glass School as a truck driver and soon after began blowing glass. Morris became very close to Dale Chihuly, taking on the role of protégé and, eventually, lead glassblower on his team. When Morris left Chihuly's employ, he established himself as a distinctive voice in the field by focusing his artistic vocabulary on nature and how earlier civilizations interacted with it.

From the beginning, Morris's blown forms have reflected the Native American, ancient Egyptian, Cycladic, and African cultures that he finds fascinating. It has been noted that "Morris identifies something fundamental in how earlier cultures tried to connote the mystery of nature, something that transcends time or historical classification."[70] He always worked in series, exploring particular themes or shapes. The series built upon one another; rarely did Morris make a complete break with the past to explore something entirely new.

In the 1980s, Morris's series concentrated on simple shapes, as in *Standing Stones*, *Stone Vessels*, or *River Rocks*. He shifted direction dramatically in the 1990s, moving toward complex forms that are closely tied to animals and artifacts, myths and history. Objects in the shape of weapons, tools, and symbols of death began to emerge from his pipe, drawing Morris's focus temporarily away from the vessel. He also began to create large-scale installations comprising hundreds of individual elements.

An early manifestation of this shift away from the vessel was Morris's short-lived *Batons* series, a group of elongated, anthropological forms that were mounted on stands. He ultimately took the idea behind these pieces and transformed it into the *Suspended Artifact Series*, complex assemblages of artifacts that hang together harmoniously. Morris has stated that, prior to being combined in groups, the individual pieces "didn't have anything to stand on, and so they didn't hold together as single objects. The associations became more important. And then when they were suspended, there was no longer any randomness and happenstance. It became very deliberate."[71]

The *Suspended Artifact Series* soon became an important vehicle for the artist to explore his increasing ability to transform glass into forms that resembled other materials. In his hands, glass became bone, ceramic, leather, or metal. Individual shapes, color, texture, and compositional balance were his paramount concerns. Morris eventually devised a system in which individual elements were blown separately and stored in the studio. Periodically, he would work on assembling the different sculptural elements until a combination felt right.[72] By 1995, when *Untitled* was made, he had introduced animal masks into the *Suspended Artifacts*. These masks further tied these pieces to his other series, such as the *Canopic Jars*, and complemented the imagery of quivers of arrows, batons, tools, pouches, and bones already in use in his sculptures.

*Untitled* from the
*Suspended Artifact Series*
**1995**
blown glass and metal
38 x 27 x 5 inches
(96.5 x 68.6 x 12.7 cm)

In 1996, Morris began the *Rhyton Series*. A natural outgrowth of his earlier *Canopic Jars* and *Suspended Artifacts*, the *Rhytons* took the form of horned animals and were inspired by a type of drinking vessel popular in ancient Greece, Rome, and Persia. As he had previously, Morris used the surface of the *Rhytons* as a canvas for abstracted patterns or, as seen here in *Untitled Bull* (1996), for the depiction of animals rendered in the style of the Lascaux cave paintings. Morris's team member Jon Ombrek adapted the pioneering technique of drawing with glass threads and crushed glass that had been developed by American artist Flora Mace. To create the animal drawings, Ombrek interpreted Morris's paper template by arranging glass powders on a heated steel surface. Morris then rolled a hot bubble of glass over the powders, thereby adhering the drawing to its surface. As the glass form was blown and shaped, the drawing expanded, appearing to come to life.

With the *Rhytons*, Morris was not preoccupied with depicting a specific animal, rather he was captivated by the idea of expressing its power. Majestic and symbolic, the *Rhytons* are important for both their technical accomplishment and the "artist's ability to evoke memories of early human experience through the essence of the animal. In his hands, the animal becomes the avatar, or incarnate spirit, of the mythic world of the human collective unconscious."[73]

After the late 1990s, Morris continued to reference ancient cultures, including their people, attributes, and spiritual beliefs, as well as the animals that inhabited these civilizations, in his work. He refined and expanded his technical skills, inspiring along the way legions of emerging glass artists. While at the height of his powers in 2007, Morris announced his retirement from glass, leaving behind a remarkable body of work made over three decades.

CS

*Untitled Bull* from the *Rhyton Series*
**1996**
blown glass
16 x 22 x 9 inches
(40.6 x 55.9 x 22.9 cm)

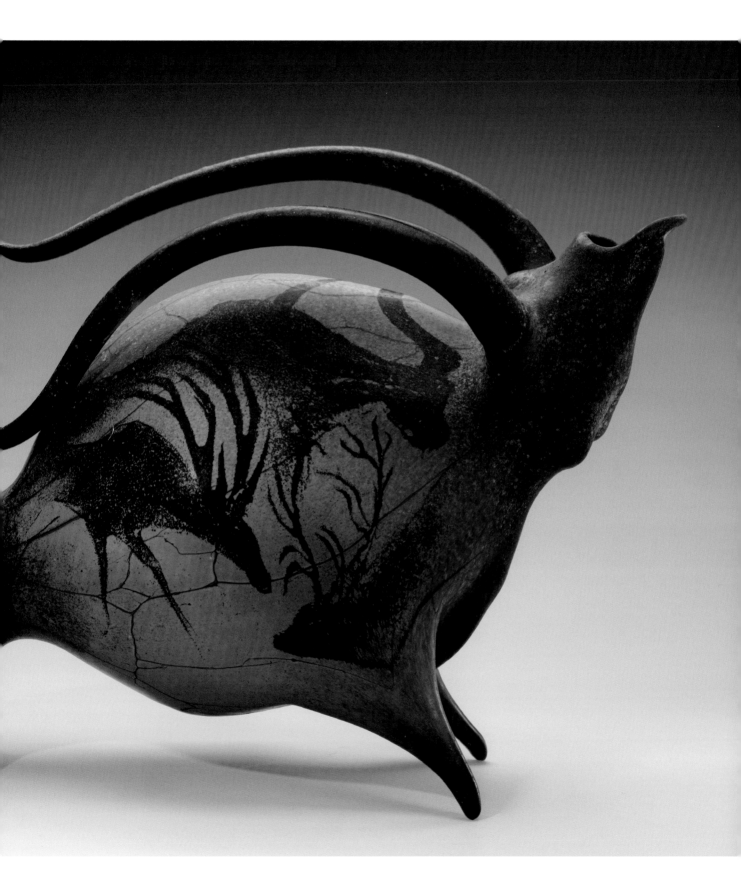

# JOEL PHILIP MYERS
American, born 1934

Joel Philip Myers's first experience with glass was as the director of design at Blenko Glass Company in Milton, West Virginia, in 1963. Though the material was new to him, Myers had long been involved in both design and ceramics. He had studied at the Parsons School of Design in New York, working as a graphic and package designer for several years before studying ceramics at the Kunsthaandvaerkerskolen in Copenhagen, Demark, and at the New York State College of Ceramics at Alfred University.[74]

Aware of the burgeoning studio glass movement, Myers began to explore the creative possibilities of the material,[75] teaching himself the techniques of glassblowing during his off-hours. His experience as a designer and maker gave him a singular perspective on the material, and his expertise was soon sought out for demonstrations, conferences, and exhibitions.[76] These early experiences, combined with the workshops held at the Haystack Mountain School of Crafts in Maine and the Penland School of Crafts in North Carolina, soon placed Myers at the center of the studio glass movement.

Myers also encouraged artists to experiment at Blenko. Notably, Marvin Lipofsky's first experience working in a factory was with Myers in 1968, catalyzing an approach that Lipofsky maintains to this day.[77] In 1970, Myers left to pursue teaching full-time at Illinois State University at Bloomington-Normal, where he influenced several generations of glass artists in his twenty-seven years as the department head.[78]

Myers began his *Contiguous Fragment Series* in the late 1970s, when a sabbatical in Austria inspired new thoughts about process and design. In this series, Myers sought to arrange color on glass in a way analogous to that of a painter working with canvas and brushes.[79] He devised a technique of applying blown glass shards to the surface of his works. Originally spherical and opaque, the vessels in the *Contiguous Fragment Series* evolved into thick lozenge shapes where fields of color appear to float and flow, freezing the movement of the once-liquid glass in a depth of thick crystal.

By the late 1980s, Myers had developed his most ambitious forms yet. Still working within the framework of the *Contiguous Fragment* aesthetic, these larger, elongated vessels were titled the *Fish and Water Series* and further elaborated on the subtle reference to water and movement.[80] *CFD White Long Hol* (1988) is an early example of this series. With shards and canes of various patterns and colors stretched across the shoulder of the vessel and suspended above opaque white glass encased in a thick layer of crystal, the design suggests images of the crisp, rushing waters of Scandinavia.

"This work has been inspired by images gathered on my annual fishing trips to Northern Scandinavia, particularly Swedish Lapland. The work reflects my impressions of that landscape, most especially the river ways and the air and the quality of light in the far north summer. The forms are physical expressions of both a spiritual and physical expansiveness which I feel in that lovely, lonely, empty part of the world."[81]

SJS

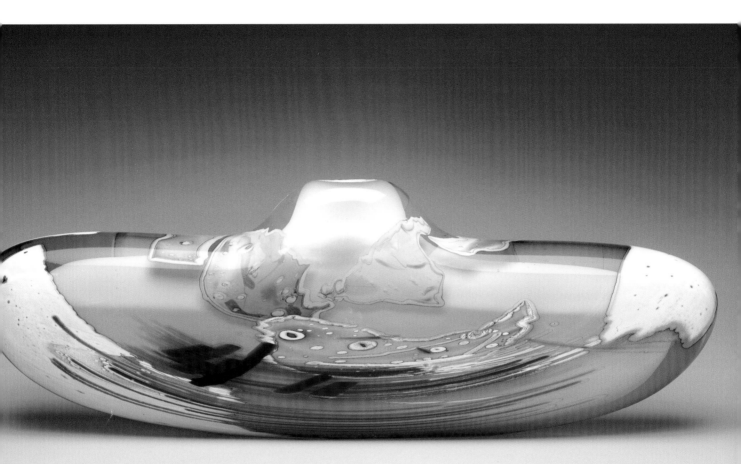

*CFD White Long Hol* from the *Fish and Water Series*
**1988**
blown glass
9 1/2 x 28 x 3 inches
(24.1 x 71.1 x 7.6 cm)

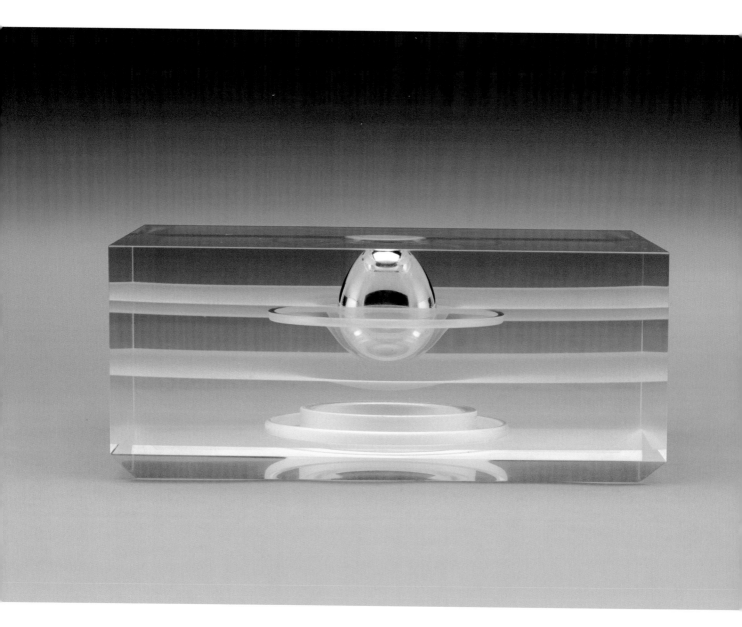

*Expanded Echo with Line* from the *Echo Series*
**1989**
glass
2 1/2 x 6 x 4 inches
(6.4 x 15.2 x 10.2 cm)

## TOM PATTI
American, born 1943

Although most American artists came to glass through other media before the early 1960s, or through intense study of glass at newly established university programs after that period, Tom Patti came to glass from an industrial-design background. He does not blow glass in the traditional sense, instead preferring to laminate common plate glass and manipulate the layers through the discreet introduction of air. Patti received his BFA (1967) and MFA (1969) in industrial design from New York's Pratt Institute. After graduation, he remained in the city and studied perceptual theory at the New School for Social Research. These studies would later become integral to his inward-projecting compositions. Patti also became involved with Experiments in Art and Technology (E.A.T.), a nonprofit group founded in 1967 to encourage collaboration between artists and engineers. E.A.T.'s mandate built on the educational foundation that Patti had received at Pratt, where he had first worked with laboratory glass, completing a series of outdoor sheet-glass sculptures.[82]

In 1970, Patti attended a class on glass at the Penland School of Crafts in North Carolina. Upon returning to his home state of Massachusetts, he set up a kiln and scavenged plate glass and Vitrolite from local building sites for his work. He soon developed his pioneering "blown laminated glass" technique to create sculptures that are at once industrial and architectural. By 1976, he had made enough work to warrant interest from Doug Heller's Contemporary Art Glass Gallery in New York.

Patti's earliest pieces reference the vessel form, but he soon came to favor more abstract or geometric designs. From the beginning of his career, he worked small and strove to eliminate any trace of his hand.[83] Critics praised his early sphered cubes for their visible laminations and "gentle cool color."[84] After 1977, Patti's glass fell into three stages: from 1977 to 1979, he inserted air bubbles into winged compositions; after 1980, he introduced edges, and his pieces became more overtly horizontal; by the late 1980s, he had abandoned the vessel form, instead focusing purely on light and structure. By the mid-1990s, Patti was also creating large-scale architectural installations.

*Expanded Echo with Line* (1989) is from of a series that Patti began in 1980 to probe the question of evolutionary versus serial production.[85] Each work in the series builds upon the piece that preceded it, and *Expanded Echo with Line* represents the peak or mature end of the series.[86] In all of the *Echo* works, Patti explored the interior space by encapsulating structural elements and inserting voids. He has said that this effect "explores my interest in expanding the peripheral, open-ended boundaries of form."[87]

According to the artist, the *Echo Series* relates directly to his monumental sculpture *Genic Doron Divider (Sentinel)*, which was commissioned by General Electric in 1984 and created at the GE Plastics World Headquarters in Pittsfield, Massachusetts.[88] This sculpture integrates space with the object through its form.[89] On a smaller scale, the *Echo* works also achieve this goal by formally addressing inner and outer landscapes within their architectonic shapes.

CS

# MARK PEISER
American, born 1938

Mark Peiser's work over the last forty years has been characterized by a commitment to excellence, exploration, and growth that is rarely seen in any medium, let alone one as technically demanding as glass. His career can be summarized into four major series: *Paperweight Vase, Inner Space, Forms of Consciousness,* and *Cold Stream Cast*. Most recently, he has begun a series based on the triumph of glassworking seen in the Palomar Observatory's massive telescope mirror, which was shaped over the course of thirteen years and completed in 1947.

When Peiser began blowing glass in 1967 at the Penland School of Crafts in North Carolina, very little technical information about equipment or glass chemistries was available. Melted #475 marbles from the Johns-Manville Fiber Glass Corporation, initially intended for producing fiberglass insulation, were the material of choice in the first studios.[90] This glass did not accept color well and had a very short working time, which impeded more elaborate investigations into process.[91]

Originally trained in electrical engineering, product design, and in piano and composition,[92] Peiser was particularly equipped to fill in the technical and aesthetic voids of the early studio glass movement. After five weeks of classes, Peiser became the Penland School's first-ever resident glass artist in 1968. Upon moving to Penland, he redesigned annealers and furnaces to make them both more energy-efficient and reliable. He undertook extensive research into glass chemistry to uncover the most appropriate glasses for small studio work, particularly for the pictorial vessels he had begun to imagine.[93] His innovations in these areas, his longstanding relationship with the Penland

School, and his continual explorations into the possibilities of glass have secured Peiser an integral place in glass history.

By 1976, he had perfected his recipe for clean, crystal glass, which allowed him to introduce transparency to his *Opaque Image Vessels,* transforming them into the masterpieces of illusion and craftsmanship of the *Paperweight Vase Series*. This series, which dates from 1976 to 1981, drew its inspiration from the natural beauty of Peiser's North Carolina home and from his own personal experience. *Hollyhocks and Butterfly* (1977) is an early example of this influential series. Using glass canes, he painstakingly created realistic scenes in perfect perspective, taking more than fourteen hours to create each work.[94] He wanted the piece to be perceived from within the scene and sought to achieve this through the excellent conception and execution of his design.

*Hollyhocks and Butterfly* is a piece whose allure is immediate, although the work's most magical aspect may be in something much more subtle. Using a torch, Peiser added each blade of grass, each stem, and each blossom individually to the surface of the hot glass before it was inflated, so that as the glass expanded the imagery would attain a lifelike realism.[95] Peiser's intimate understanding of the material has allowed him to create pristine and masterful works in which the possibilities of thick, optically active walls of crystal are used to maintain and elaborate perfect perspective.

SJS

*Hollyhocks and Butterfly* (PWV 45) from the *Paperweight Vase Series*
**1977**
blown glass and cased glass with torch-worked imagery
6 1/4 x 6 1/4 inches diameter
(15.9 x 15.9 cm diameter)

*Estasi*
**2000**
blown glass and Bardilio marble
18 x 17 1/4 x 7 inches
(45.7 x 43.8 x 17.8 cm)

# LIVIO SEGUSO
Italian, born 1930

Livio Seguso began his career as a glass artist in Murano, Italy, as a young apprentice in his uncles' factory, Vetreria e Soffieria Barovier Seguso & Ferro. There he studied centuries-old Muranese glass techniques with the factory's *maestros*. He also attended drawing classes at a local academy, where he was taught by Vittorio Zecchin, a painter, decorator, and designer who is credited with bringing the Vienna Secession style to Murano. His training was further augmented when, in 1950, Seguso was asked by another uncle, the legendary glass designer Alfredo Barbini, to join him at his new factory, Vetreria Alfredo Barbini. By the end of the decade, a now-proficient Seguso had formed a partnership with the painter Luciano Gaspari to produce innovative glassware for Salviati, a firm that had previously focused on traditional forms.

As a successful artist and glassblower for industry, Seguso could have simply continued in that vein. However, during the 1960s he undertook research into experimental glass-making processes that produced sculptural works made from crystal glass.[96] These pieces marked the beginning of his second career as a studio-glass artist. Seguso's success in achieving his objectives led him to establish a studio in Murano in 1968. For the first time, he could now focus purely on sculpture. By the early 1970s, certain characteristics that would become hallmarks of his style could already be identified, including the almost exclusive use of colorless crystal glass, formal design elements, and the duality of reason and sentiment, rationality and emotion.[97]

Seguso's glass of the late 1970s to 1990s focused on light and matter. Complex configurations that contained circular or ovoid spheres of light gave way to the use of Lucio Fontanaesque "cuts" that dissembled and unbalanced geometric forms. The introduction of first steel, then marble or stone, as a counterpoint to glass in his sculptures of the mid-1980s offered alternative solutions to issues of form and structure. Although he initially used these materials in small quantities as accents, by the late 1980s he employed them in equal ratios to glass. In the 1990s, Seguso pushed his sculpture beyond the ovoid, realizing a series of plantlike elements that coalesced in harmonious installations. However, he soon returned to his more characteristic vocabulary of spherical forms.

*Estasi* (Ecstasy) from 2000 recalls Seguso's experiments from the mid-1980s with combining glass with marble. However, in these recent sculptures, he took a more complex approach to form and materials. The marble is now a distinct structural entity that coexists with the glass sphere rather than being fully integrated with it.[98] Texture and the use of gray, rather than white, marble also set this sculpture apart from earlier works.

Seguso is renowned in his native Italy and has exhibited his art throughout the world. As one of the few Italian studio-glass artists working today who has successfully defined his work more as sculpture than glass, he holds a distinct place in the field—one that inspires his contemporaries as he straddles the line between tradition and innovation.

CS

# MARY SHAFFER
American, born 1947

Over the course of four decades, Mary Shaffer has worked outside the traditional boundaries of the glass field. Shaffer came to studio glass through painting and illustration, earning a BFA from the Rhode Island School of Design (RISD) in 1965. Her early work consisted of painting on glass, shaped into undulating canvases that reflected windows. In 1972, in what would become a defining moment in her career, the glass artist Fritz Dreisbach, who was substituting for Dale Chihuly at RISD, saw her glass paintings and suggested that she investigate slumping glass. By that time, slumped glass was already a favorite technique of studio-glass artists because it could be executed in a small kiln. It was also widely used in industry to manufacture objects such as windshields.

Shaffer's approach to slumping glass was experimental from the beginning. There was little information available on using the technique without a mold, and Shaffer wanted to capture the material's molten state, a goal impossible to achieve with a mold. In particular, she aimed to freeze glass at certain points in its melting process—what she ultimately called "mid-air slumping." After developing a variety of support armatures and testing how much pressure the glass could tolerate without breaking, Shaffer discovered that she could fuse, weld, cut, or fracture glass by applying varied degrees of heat.[99] Ultimately she settled on a slumping process that began with firing plate glass in a kiln, followed by introducing a support structure and then letting gravity take over.

Shaffer has explored themes throughout her career. Indeed, she has been described aptly as an artist who has the "ability to compound a series of innovations into a language that permits a consistent unfolding of expression."[100] In the 1970s, Shaffer, like many artists of her generation, became interested in using found objects as a vehicle for expression in her art. Combining the solidity and rigidity of metal tools, nails, wires, and other objects with the fluidity of slumped glass, she offered an alternative to the blown vessel or narrative sculpture. By the 1980s, she was alternating between making large-scale sculptures and smaller works that grew out of her early tool-and-wire test pieces. All of these pieces explore the dichotomies inherent in pairing a fragile, translucent, and fluid material such as glass with the strong, opaque solidity of metal.

Shaffer began the *Cube* series in the late 1980s. According to the artist, the series began by accident during a residency at Wheaton Village in Millville, New Jersey, when a collector walked into her space and saw a mock-up and inquired whether it was available.[101] This inquiry gave Shaffer the impetus to complete a work based on the test piece, and she ultimately made a number of *Cube* pieces, such as *From Cube IV* (1992), seen here.[102] By pairing the solidity and perceived weightiness of the metal geometric cube with free-flowing glass, she mediated between illusion and gravity. Like water spilling from a tap, the graceful shape and curve of the glass seem effortless and beyond human control.

CS

*From Cube IV*
1992
glass and bronze
32 x 9 1/4 x 5 3/4 inches
(81.3 x 23.5 x 14.6 cm)

# PAUL STANKARD
American, born 1943

A true pioneer of contemporary glass, Paul Stankard originally trained as a scientific flameworker at Salem Community College in Pennsgrove, New Jersey, beginning in 1961.[103] Upon graduation, he worked in several scientific laboratories, but soon grew bored with the repetitive tasks of industry and began looking for other avenues for his burgeoning talent. On this search, he encountered the studio glass movement and the traditionally secretive world of paperweight makers.[104]

In the 1960s and 1970s, neither the technique of flameworking (using a torch to melt glass) nor the format of the paperweight was accepted as viable for creative glasswork.[105] Nevertheless, Stankard began exploring the potential of the flameworked paperweight, using his lifelong interest in wildflowers as a starting point. He completed his first pieces in 1969 and by 1972 had experienced enough success to pursue this endeavor full-time.[106] Stankard's masterful works and his dedication to education are largely responsible for the acceptance of both flameworking and the paperweight form today.

Stankard researches flowers for his works through intensive study of photographs and books, and also through time spent outdoors, but he is more interested in creating an "organically credible" universe than in directly reproducing its forms.[107] This magical realism[108] is exemplified in his "root people," who, in this piece, form an embracing, writhing root structure supporting the bouquet above. The appeal of Stankard's work lies in the excellence of its illusion. Each petal, stem, and leaf is carefully composed and assembled. A gather of optical crystal is then melted and "dropped" over the imagery. A perfect balance in temperature allows the hot glass to flow over the delicate forms without cracking, distorting, or trapping air bubbles.[109]

Although his work has been made in much this way since the beginning of his production, two important developments occurred in the late 1980s. Stankard shifted from the domed shape of the paperweight to a columnar form, which he called the *Botanicals*.[110] This innovation allowed him to make the flowers and root systems in separate stacked sections, essentially doubling the amount of visual information in each piece. The second innovation was the addition of laminated, dark glass to the sides of the pieces as a border for his floral imagery. By defining the visual field, this cloistering[111] gave Stankard's botanicals a frame in which to be seen and glorified. In this untitled *Cloistered Botanical* from 1990, both innovations appear to great effect. Though diminutive in size, this piece offers grand opportunities for contemplation.

SJS

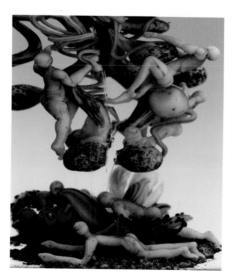

*Untitled* (and detail)
1990
glass
5 5/8 x 2 3/4 x 2 7/8 inches
(14.3 x 7 x 7.3 cm)

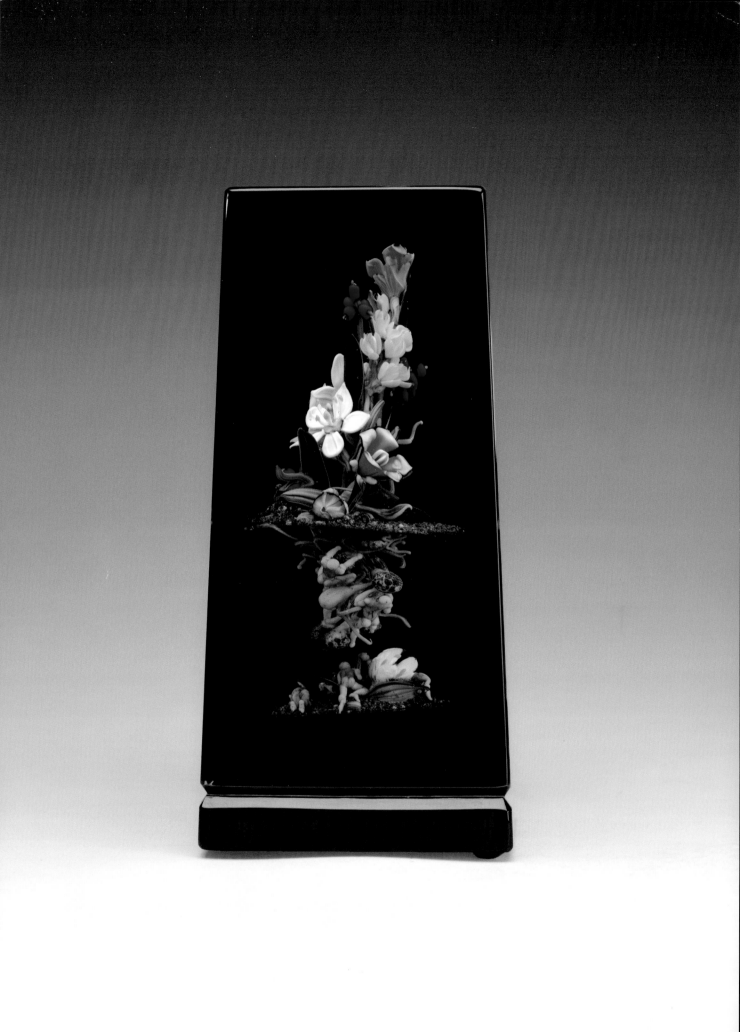

# THERMAN STATOM
American, born 1953

Therman Statom is best known for his architectonic installations and assemblages that incorporate plate glass, blown-glass shards, painted surfaces, and the artist's own distinctive language of symbols and signs. Statom was brought up in Washington, D.C., where visits to museums led to his interest in art. In 1971, he enrolled in the ceramics program at the Rhode Island School of Design (RISD), where he became lifelong friends with influential ceramicist Jun Kaneko.[112] After seeing emerging professor Dale Chihuly and his students experiment with glass and ice in the RISD studio, Statom switched his focus.[113] His first glass class was with Fritz Dreisbach, a major player in the development of studio glass.[114]

Statom attended the Pilchuck Glass School in the summer of 1971, and graduated from RISD in 1974 with a BFA in sculpture. The following year, he enrolled at the Pratt Institute in New York, where he made his first works with plate glass because of the lack of hot-glass equipment. Statom received his MFA in sculpture in 1978,[115] and in the early 1980s, he was invited by Richard Marquis to visit his program at the University of California, Los Angeles. Statom would run the program after Marquis's departure in 1983 until its closing in 1985.[116]

A mainstay of Statom's work is his large-scale installations, which sometimes span several thousand square feet and incorporate both glass constructions and site-specific paintings. By the late 1970s, Statom had begun making a series of stand-alone sculptures to complement these site-specific works. Focusing on four forms, the ladder, house, chair, and "painting" (a painted assemblage of glass boxes), these sculptures arose from the artist's desire to create a consistent canvas for his paintings.[117] Statom's objects combine personal and art-historical references into seemingly spontaneous expressions, though on closer inspection, each color choice and stroke is clearly deliberate. Statom adds shards, found objects, and blown-glass elements to these constructions, usually encasing them in the plate-glass structures, but sometimes allowing them to function outside of these sealed environments.

*Chair* (c. 1992), comprising a full-scale chair, is made from glued sheets of plate glass, painted in the artist's distinctive graphic style, and a series of glass objects and shards placed on a platform. Each element has its own meaning—some are readily deciphered, while others remain elusive. *Chair* maintains the exuberant power of Statom's installations; it is imposing yet approachable, simple yet highly nuanced, and offers insight into the artist's world of association, freedom, and transformation.

In recent years, Statom has dedicated a significant portion of his time to teaching children both in the course of his installations and as a visiting artist at schools and camps, and he sometimes incorporates their drawings into his work. In addition to receiving two fellowships from the National Endowment for the Arts, he has been named a fellow of the American Craft Council and has received the Distinguished Artist Award from the James Renwick Alliance.[118]

SJS

*Chair*
c. 1992
glass with mixed media
53 x 48 x 32 inches
(134.6 x 121.9 x 81.3 cm)
The Museum of Fine Arts, Houston,
gift of Barbara and Dennis DuBois,
2008. 450. A-.C

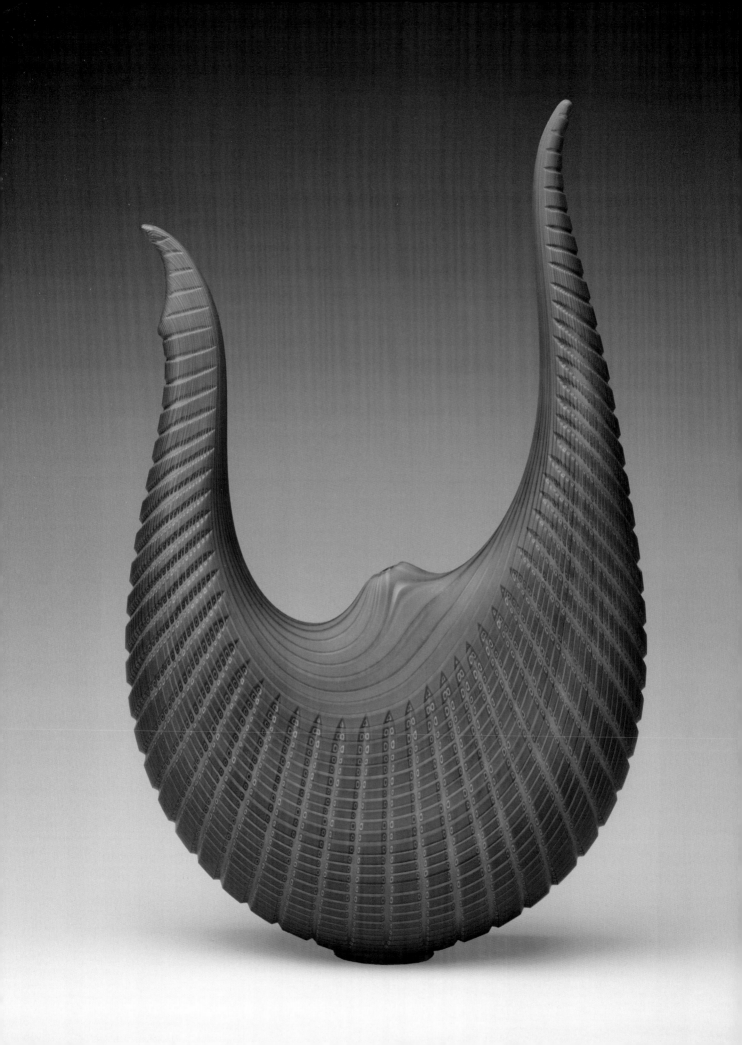

# LINO TAGLIAPIETRA
Italian, born 1934

Lino Tagliapietra is often hailed as the "Italian Maestro" of glass. In the Italian tradition, the term *maestro* refers to the lead glassblower in a factory's team. When applied to Tagliapietra, however, the honorific title acknowledges not only his incredible skill with glass, but also his evolution from artisan to studio artist and influential teacher.

Unlike many other studio-glass artists, Tagliapietra received virtually no academic training, let alone schooling in art, design, or glass. Raised on Murano, he dropped out of school at age ten and became an apprentice in the glass factory of Archimede Seguso at age twelve; by twenty-two, he had attained the title of *maestro* while working for Galliano Ferro. For the next twenty-five years, Tagliapietra worked for a succession of other Muranese glass companies, executing their designs. By the mid-1960s, armed with an intimate under-standing of glass, he developed his own designs for lamps and decorative vessels, several of which went into production in the 1970s.[119]

*Batman*
**1998**
blown glass
14 x 9 x 3 inches
(35.6 x 22.9 x 7.6 cm)

Tagliapietra joined the American studio glass movement when, in 1979, he was invited to teach a summer workshop at the Pilchuck Glass School.[120] His demonstration of a seemingly endless variety of complex techniques awed his American students, and deepened their respect for craftsmanship at a time when many viewed it as subordinate to artistic ideas. What the Americans lacked in skill, however, they made up for in enthusiasm and in an experimental attitude that affected Tagliapietra's approach to his medium as much as his expertise affect-ed theirs.[121] Since 1979, Tagliapietra has taught frequently at Pilchuck and other schools, and the influence of his Venetian techniques has been noted in much of the studio glass produced from the 1980s to the 1990s.[122]

During those years, Tagliapietra gradually transitioned from working for industry to working independently as a studio artist,[123] eventually synthesizing an incredible range of techniques into new and distinctive forms. In the *Batman* series, begun in 1998, the artist transformed the Bat Signal into unexpectedly elegant abstract sculptures. On this 1998 example, the attenuated, stylized bat wings arc gracefully upward in a U-shaped form, delineated further by parallel blue and greenish-yellow lines. Offsetting these lines are a series of vertical cuts that expose a layer of white inside the blue glass canes as well as the greenish-yellow underlayer, creating a rich visual and tactile texture that has been likened to reptile skin as well as to woven basketry.[124] Tagliapietra has described the subject of this series as "a creature who emerges from his dark cave to share goodness and light," and has stated that "when you ask someone to talk about his work, you are asking him to reveal a secret part of himself." In this way, the work is a metaphor for the artist's role, and the contrast between its radiant form and the shadow it casts "allow[s] the viewer to see both the reality and fantasy of Batman's world."[125]

RE

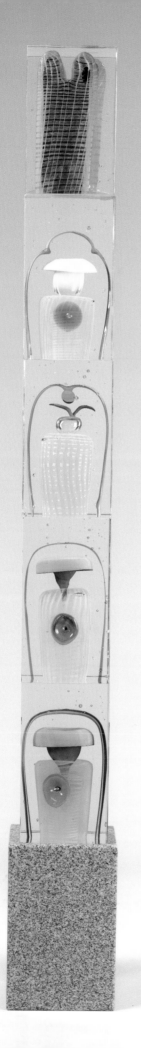

# OIVA TOIKKA
Finnish, born 1931

Oiva Toikka is among the youngest of the generation of designers to revolutionize Finnish design in the second half of the twentieth century. Toikka originally trained as a ceramicist and was employed as a ceramic designer at Arabia Ceramics Factory, Nostjo, and of textiles at Marimekko Textile Factory.[126] Then, in 1963, he was invited by Kaj Franck to join the glassworks at Nuutajärvi Glass Factory, which at the time placed great emphasis on individual artistic output in addition to designing for industry.

As Finnish design legend Kaj Franck stated in 1958, "A designer who only designs for industry will finally produce designs that are very thin and superficial. There shouldn't be any set relationship between art and industrial design because everyone has different capabilities. One should be flexible enough to do many different things well that demand an assortment of skills—and still keep a central interest."[127] Though Toikka and Franck had very diverse aesthetic approaches and personalities, the two shared a studio for many years.[128]

Toikka dedicated himself fully to his new medium, and as early as 1963 was exhibiting wildly inventive pieces, such as his thick-bottomed *Pickle Jars,* in addition to his utilitarian glass designs. By the early 1970s, his experimental and innovative nature manifested in works such as *Lake Palace, Aeolian Harp,* and *Lollipop Isle.*[129] Combining blown elements inside of hot-cast pieces to make scenic assemblages, these free-form, exuberant pieces are precursors to his more mature paperweight assemblages.

*Lemon Road* (1989) is a wonderful example of Toikka's work in this later style. Using energetic colors and repetitive, biomorphic forms that seem frozen within blocks of polished clear glass, *Lemon Road* is imbued with a powerful, playful presence. Toikka is among the first to use the technique of encapsulating three-dimensional forms within a solid block of crystal, and this technique, combined with his commitment to his aesthetic vision, has opened new approaches and possibilities for the material.

Toikka has been a visiting professor at both Konstfack (University College of Arts, Crafts and Design) in Stockholm, Sweden, and at the University of Sunderland in the United Kingdom, from which he was awarded an honorary professorship in 1989.[130] In 2001, he was awarded the prestigious Prins Eugen Medal from the King of Sweden for lifetime achievement in the arts.[131] Though his non-industrial work remains virtually unknown in the United States, his influence on the development of European studio glass cannot be discounted. From his early shows with Bertil Vallien and Kaj Franck to the evidence of his paperweight technique in the masterful work of Danish artist Steffen Dam, the innovative and inventive work of Oiva Toikka has made a lasting impression on studio glass.

SJS

*Lemon Road* (and detail)
1989
cast glass
53 x 6 1/4 x 5 inches
(134.6 x 15.9 x 12.7 cm)

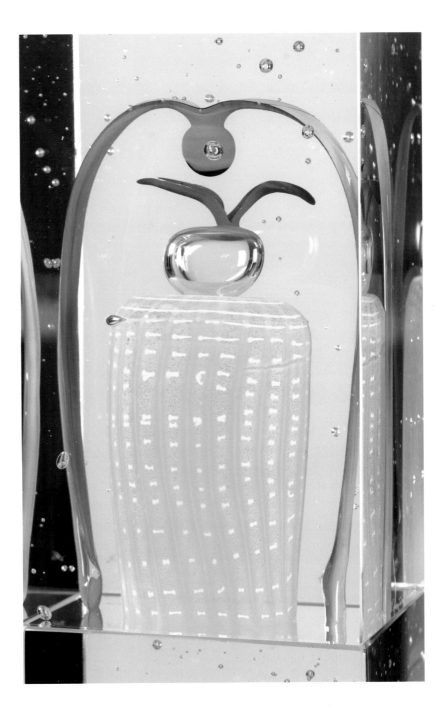

# BERTIL VALLIEN
Swedish, born 1938

A sculptor in glass and a designer of factory-made functional glassware for over forty years, Bertil Vallien disproves the belief, common among American studio-glass artists during the early years of the movement, that the two activities are philosophically opposite, mutually exclusive pursuits.

Vallien studied industrial design and ceramics at Stockholm's Konstfack, graduating in 1961; both aspects of his training would later inform his work in glass. He spent the following two years working in the United States as a designer for a Los Angeles-based ceramics company while also continuing his own work as a ceramicist. There, he was influenced by the daring attitude of California ceramicists toward their medium.[132] In 1963, he returned to Sweden to work part-time as a designer for the Åfors glassworks, using the rest of his time in the facilities for his own artistic explorations.

Already proficient as a sculptor in clay, he saw artistic potential in glass, but sought to adapt his clay-working methods to the medium. He developed an innovative sand-casting technique in which he molds the negative of the desired shape in wet sand and then fills the impression with hot glass.[133] Over the years, Vallien has refined this concept, using dies to create protrusions on the surface of forms and negative spaces inside them. He also adds smaller objects to the molten glass, encasing them within the sculptures.

Vallien's sculptural glass explores the nature of consciousness, dream states, and death, in tandem with themes of journeys, transformations, and the passage of time. Since the late 1970s, he has used boats as a leitmotif to powerfully evoke these themes. In the

Viking culture of Vallien's ancestors, boats were used to bury the dead, with the idea that these vessels would carry their human cargo to the next realm.[134]

With the *Pendulum* series, Vallien has taken this motif in a new direction, transposing the boats into a vertical form. The title connotes a state of transition, of something hanging in the balance. The forms reference the double meaning of "vessel" as both a boat and an urn, and also evoke the human figure. Contained in these vessels, glass resembles water or ice in which other symbolic objects seem to float, frozen in a state of suspended animation. Embedded in *Pendulum V* (1992) are several small human figures and objects that appear like microscopic organisms in a watery, primordial, and timeless world. Sand casting imparts a rough texture to much of the back of the work, giving it the look of an archaeological artifact. Vallien has consciously controlled the way that light illuminates the sculpture, rendering its top transparent and its base relatively opaque. The object suggests both a mystical being, glowing with inner light, and a scientific specimen. The enigmatic qualities of *Pendulum V* invite multilayered interpretations—perhaps the sculpture represents a dialogue between one's inner and outer selves, between present and past selves, or even between ancient and present-day humankind.

RE

*Pendulum V* (and detail)
1992
cast glass and metal
87 1/4 x 13 5/8 x 13 5/8 inches
(221.6 x 34.6 x 34.6 cm)

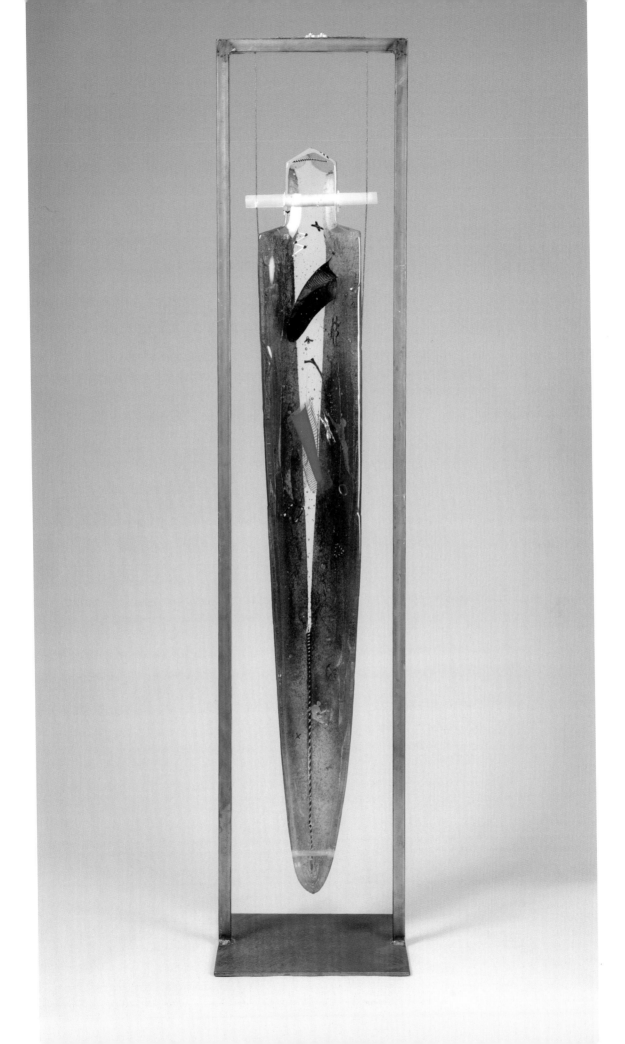

# FRANTIŠEK VÍZNER
Czech, born 1936

The Czech artist František Vízner is world-renowned for his unique approach to and mastery of glass cutting. He initially studied at a glass school in Nový Bor, where he accepted a glass-painting apprenticeship at the age of fifteen. From 1951 to 1953, Vízner attended the newly reopened glass school in Železný Brod, studying with the innovative glass-cutting professor Jan Cerny.[135] After graduating, he entered the prestigious Academy of Applied Arts in Prague,[136] where the visionary professors Josef Kaplický and Karel Štipl were training a new generation of glassworkers with a sculptural sensibility.[137]

It was an interesting and oddly enlivening time to study glass in Czechoslovakia. Although the censorship that accompanied the Communist coup of 1948 had had a chilling effect on the "fine" arts of painting and sculpture, glassmaking was experiencing a resurgence and revitalization as had never been seen before in Bohemia. While Kaplický was exploring the relatively new technique of large-scale kiln casting, Štipl was advocating a revolution in the traditionally Czech technique of glass cutting, known as "glyptography." Vízner studied with Štipl, who promoted the sculptural use of glass cutting in conjunction with an architectonic sense of form and excellent craftsmanship.[138]

Afterward, Vízner spent five years as a designer for the glass-pressing industry at the Sklo Union Glassworks in Teplice.[139] As one of the first designer-artists to be employed by the industry, Vízner made great strides in applying the process, implementing many designs that continued to be produced after his departure from the factory. He has said: "The presser's freedom in shaping the base, and especially the architecture of the quadratic shape, can still be seen in my work. Pressing makes possible yet another beautiful detail: the conscious shaping of the cavity of the object—a cavity without accidental romance and inaccuracies. Lately, I have returned to the principle of pressed technology. I shape the cavities of the objects quite intentionally and increase their number in a single vase; this is something which I have been working on for a long time."[140]

Vízner begins with a solid block of glass weighing upward of eighty-eight pounds[141] and uses stencils, grinding wheels, and diamond tools to carve the initial form. Then hours of hand sanding, followed by sandblasting and acid etching, render the perfect surfaces for which Vízner is known. This 1993 "bowl with a peak" is an example of one of Vízner's most iconic shapes, which he designed in a series of drawings between 1964 and 1965. By 1971, the piece had still not gone into production, and so Vízner created the first one himself, predating his solo studio practice by six years.[142] Since that time, he has continued to employ this shape, still finding inspiration in its perfectly resolved, elegant simplicity. The gently sloping, thinning curves allow light to articulate the form, displaying the depth of Vízner's characteristic rich colors. Through his singular dedication to his aesthetic vision, Vízner has helped redefine the concept of the vessel and has forged entirely new possibilities from the most classic of forms and techniques.

SJS

*Untitled*
1993
glass
3 1/2 x 11 3/4 x 11 3/4 inches
(8.9 x 29.8 x 29.8 cm)

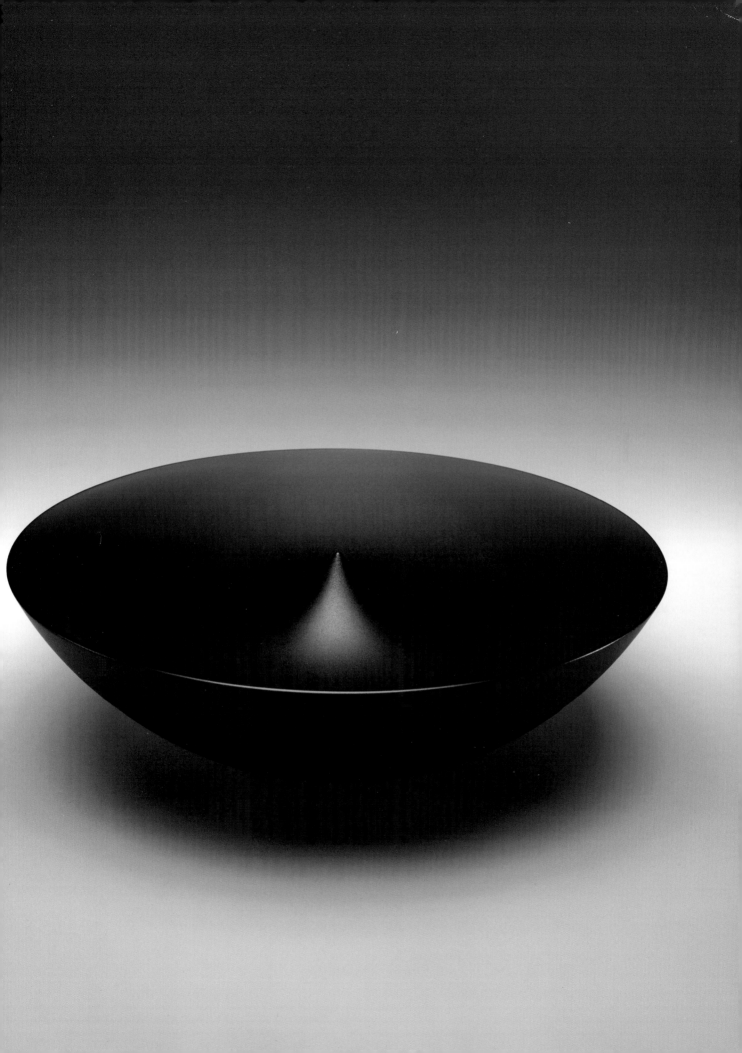

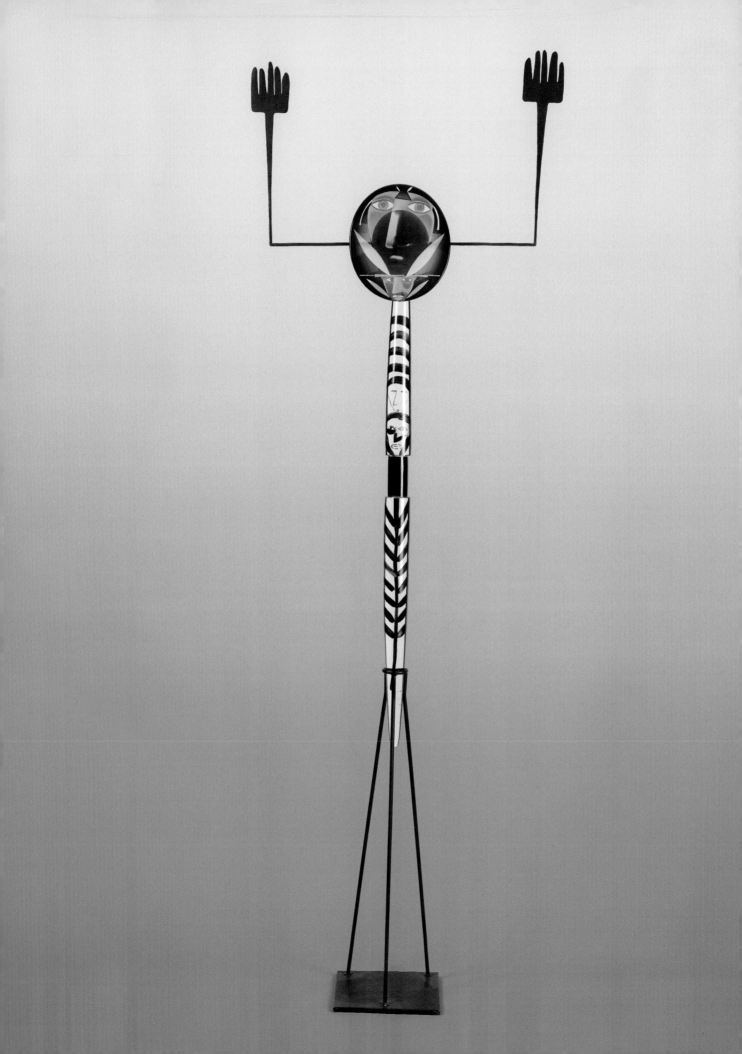

# ANN WOLFF
German, born 1937

Ann Wolff was educated as a designer at the Hochschule für Gestaltung in Ulm, Germany, in 1959. A year later, she married the glassblower Goran Warff and moved to Sweden. There she designed glass for factory production for almost twenty years, first at the Pukeberg Glassworks (1960–64) and then at Kosta Boda (1964–78). During her time at Kosta Boda, she began to gain an awareness of the developments of the American studio glass movement. Interested in the idea of producing objects without the "social responsibility"[143] of industrial design, Wolff began exploring the artistic possibilities of the material during the time allotted for free exploration with the glassworkers.[144]

In 1977, Wolff won the first prestigious Coburger Glaspreis [Coburger Glass Prize] for Modern European Studio Glass, hosted by Kunstsammlungen der Veste Coburg and the Museum für Modernes Glas, in Coburg, Germany, and in 1978 founded her own studio in Vaxjo, Sweden. Her initial studio-glass works were richly colored, poetic vessels created with an overlay technique. She sensitively sandblasted and engraved their surfaces to reveal figures, usually female, involved with the tasks and objects of everyday life. Wolff's work employs images related to her own experience, so it is natural that images of domesticity and femininity appear prominently. But such associations are not the direct focus of her work; rather, her personal vocabulary of color, form, and imagery conveys the complexities of relationships, whether familial, professional, or personal.[145]

*Nut's Daughter,* from 1987, is derived from the story of the Egyptian goddess Nut, ruler of the sky and guide for the dead. In the tombs of great kings, Nut appears arched, arms and legs extended, supporting the heavens on her back, ready to swallow the sun as it traverses the sky, shielding her earthly family from the chaos of the cosmos and offering them eternal solace in the heavens.[146] In Wolff's interpretation, Nut's offspring appears with arms raised and fingers spread, rising to her full height as if to fend off an attack, in spite of her exaggerated fragility. Her even and sorrowful gaze is fixed upon the viewer, demanding contemplation, and she appears to have swallowed the sun. *Nut's Daughter* is from a small series of sculptural works that juxtaposes the strength of female archetypes and the sensitivity and emotion of their painterly countenances.[147] The seeming unease between the fragile simplicity of their forms and the graphic complexity of their faces gives these works their presence.

In 1989, Wolff turned her attention to drawing, printmaking, and creating layered, expressive glass collages. In 1991, at the suggestion of the Czech glass artist Jaroslava Brychtová, she began to experiment with kiln casting, creating powerful monochromatic, figural objects.[148]

Wolff's activities within the emergent glass communities of Northern Europe and the United States in the 1970s and beyond, through numerous lectures, workshops, and classes, have secured her place in glass history. Yet her legacy also arises from her commitment to self-discovery and exploration, the freedom to move and to change, and above all the emotional content of her objects.

SJS

*Nut's Daughter*
1987
glass, enamel, and metal
79 x 26 1/2 x 6 inches
(200.7 x 67.3 x 15.2 cm)

## TOOTS ZYNSKY
American, born 1951

Toots Zynsky uses glass threads to create color-saturated, expressionistic vessels that are not only sculptural, but are also reminiscent of paintings and textiles. Her innovative technique, which evolved from her artistic training, represents an original contribution to studio glass. As an undergraduate studying painting at the Rhode Island School of Design (RISD) in the early 1970s, Zynsky had become dissatisfied with that medium and was thinking of leaving school when she discovered RISD's glass department and saw a whole new world of possibilities.[149] Through a summer course at the Haystack Mountain School of Crafts, in Deer Isle, Maine, as well as through coursework at RISD with Dale Chihuly, Zynsky mastered a range of glassworking techniques. She also was among the original group of students who helped Chihuly establish the Pilchuck Glass School in 1971. She received her BFA from RISD in 1973, and returned there in 1979 to take an additional course in the school's glass program. At that time, she began making blown-glass forms with applied glass strands.

The early 1980s witnessed Zynsky's increasing interest in the fragility and brittleness of glass, and she commenced crafting vessels entirely from strands of glass made from colored glass rods that are heated and stretched thin.[150] Using a process that she has described as similar to making a drawing or painting,[151] Zynsky places up to thirty layers of glass threads on a ceramic surface to form the body of the piece. She then arranges the final layer of glass threads into an abstract composition in which they resemble brushstrokes of paint. The glass is then heated to fuse the threads into a sheet, which is placed over a mold to create a vessel form. Finally, with gloved hands, the artist manipulates the vessel while hot, creating delicate folds that allow the glass to take on the appearance of fabric.[152]

Zynsky's compositions are produced in series, inspired by the bright colors of nature and of textiles and architecture that the artist has seen during her travels. The *Tierra del Fuego* series refers to the island on the southern tip of South America whose name, Spanish for "Land of Fire," derives from fires burned day and night by the native people. Zynsky's works also reflect her trip to Ghana in 1984, an experience that broadened her understanding of how color could be used in her own work. While there, she collaborated with a Ghanaian weaver to create a kente cloth and visited a market where merchants sold colorful yarns.[153] On works such as *Lady in a Blue Chair* (1990), the rough edges, the folds, and the patchwork layering of the threads evoke the visual richness of those yarns and textiles, while the daring combination of contrasting colors creates a sense of vibrancy and energy.

RE

*Lady in a Blue Chair*
from the *Tierra del Fuego* series
1990
Filet-de-verre
(fused and thermoformed glass threads)
10 x 7 x 5 1/4 inches
(25.4 x 17.8 x 13.3 cm)

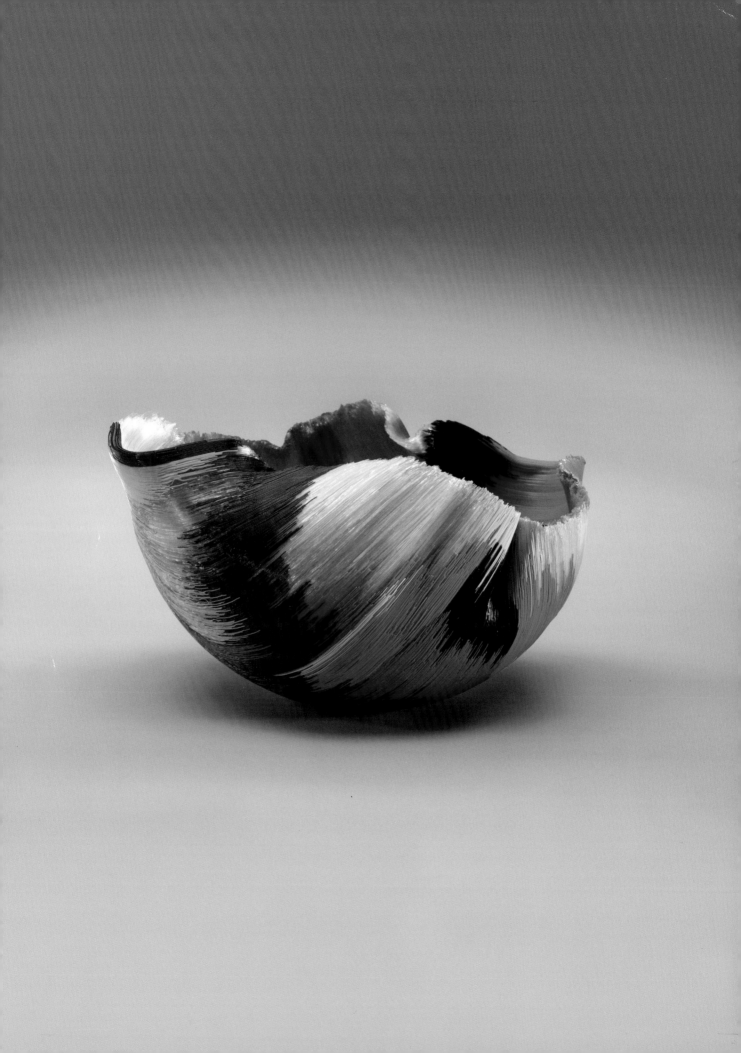

## Notes

1   Howard Ben Tré, "A Conversation with Howard Ben Tré," interview by Diana L. Johnson, in *Howard Ben Tré: New Work* (Providence, RI: Brown University, 1993), 6. Ben Tré initially attended Missouri Valley College from 1967 to 1968 and Brooklyn College from 1968 to 1969.

2   Howard Ben Tré, "Interview with Howard Ben Tré," interview by Patterson Sims, in *Howard Ben Tré* (New York: Hudson Hills Press in association with the Scottsdale Museum of Contemporary Art, 1999), 45.

3   Ben Tré, "A Conversation," 6–7.

4   Martha Drexler Lynn and Barry Schifman, *Masters of Contemporary Glass: Selections from the Glick Collection* (Indianapolis: Indianapolis Museum of Art, in association with Indiana University Press, 1997), 41. Bonded sand is a mixture of sand and chemicals that later hardens like concrete.

5   Chihuly began experimenting with melting and fusing glass in 1961; in 1963 in a weaving class, he made experimental tapestries using glass pieces and copper wire. See Donald Kuspit, *Chihuly*, 2nd ed. (Seattle: Portland Press, 1999), 339–40.

6   Chihuly was invited to RISD by Norman Schulman, a ceramicist who had participated in Harvey Littleton's workshops at the Toledo Art Museum in 1962 and who subsequently introduced glass into the curriculum at RISD. Chihuly took over the program in 1969 and served as its head until 1981. For a description of Chihuly's arrival at RISD, see Marvin Lipofsky, transcript of an interview by Paul Karlstrom, Berkeley, California, July 30–31 and August 5, 2003, for the Nanette L. Laitman Documentation Project for Craft and Decorative Arts in America, Smithsonian Institution Archives of American Art. Available online at http://www.aaa.si.edu/collections/oralhistories/transcripts/lipofs03.htm.

7   Dale Chihuly, in Bonnie J. Miller, *Out of the Fire: Contemporary Glass Artists and Their Works* (San Francisco: Chronicle Books, 1991), 30.

8   *Macchia* is the Italian word for "spot."

9   The official view on art was that it must be created in a Social Realist style that supported the Communist agenda; modernist concerns such as abstraction were not an acceptable avenue of exploration. Although this view strongly impacted the fields of painting and sculpture, glass was considered a functional, and therefore more innocuous, medium, and escaped much of this censorship. Further, because the glass factories played such a vital role in the Czech economy, innovation in that medium was encouraged, and it is therefore not surprising that glass became the focus of artistic expression. See Helmut Ricke, ed., *Czech Glass 1945–1980: Design in an Age of Adversity* (Stuttgart, Germany: Arnoldsche Art Publishers, in association with the Museum Kunstpalast Düsseldorf, 2005).

10  Alena Adlerová, "An Interview with Václav Cigler," *Glasswork: A Quarterly Magazine on Glass* 10 (October 1991), 4; and Tina Oldknow, "Painting and Sculpture in Glass: Czech Design Drawings from the 1950s and 1960s in The Corning Museum of Glass," in *Czech Glass 1945–1980*, 64–66. See also Antonín Langhamer, "Czech Specialized Schools for Glassmaking and Schools of Applied Arts: 1945–1990," in ibid., for further discussion of the Academy of Applied Arts and Kaplický's pedagogy. Both Stanislav Libenský and František Vízner, two other Czech artists represented in the DuBois Collection, also studied with Kaplický.

11  Quoted in Oldknow, "Painting and Sculpture in Glass" in *Czech Glass*, 66.

12  Quoted in Dan Klein, *Artists in Glass: Late Twentieth Century Masters in Glass* (London: Octopus Publishing Group, 2001), 44–45.

13 Dan Dailey, as quoted in William Warmus, "Make It Real," in *Dan Dailey*, ed. Joe Rapone (New York: Abrams, 2007), 25.

14 Dan Dailey, correspondence with Cindi Strauss, September 22, 2008.

15 Ibid.

16 Ibid.

17 Ibid. Dailey had recently read a biography of Cellini that detailed his private life.

18 Warmus, "Make It Real," in *Dan Dailey*, 15.

19 Dailey, correspondence with Strauss.

20 Erwin Eisch, from an address at the Glass Art Society Conference in Corning, New York, 1979, and published in the *Glass Art Society Journal* (1979): 10.

21 Susanne K. Frantz, "Sources of Inspiration," *Crafts*, no. 153 (July/August 1998): 98.

22 Erwin Eisch, "Eisch Memories" in *The Story of Studio Glass*, ed. Finn Lynggaard (Copenhagen: Rhodos, 1998), 35–36.

23 From the Eisch Web site, http://www.eisch.de/eng/website/history/history.php. For a more developed sense of Eisch's role as "Spiritual Father," see his artist statement in the catalogue titled, *Erwin Eisch*, from his exhibition at the Maurine Littleton Gallery, Washington D.C., October 1987, and his lecture, "The Glass Artist's Survival," in the *Glass Art Society Journal* (1995): 52–55. Eisch is among the most outspoken in calling for an examination of the soul, individuality and personhood in the studio glass movement.

24 Erwin Eisch, "Speech on the Occasion of the Coburg Glass Award, 1985," as quoted in Peter Kobbe, "Contemplative Flesh, Thoughts on the Art of Erwin Eisch," *Neues Glas* 2 (1986): 78.

25 Thomas Buechner, "Erwin Eisch," *American Craft* 42, no. 5 (October/November 1982): 22–23.

26 Gruppe SPUR Manifesto, 1958, written in German and translated by *NOT BORED!* in June 2005 from the French version published in *Archives Situationnistes: Volume 1: Documents traduits 1958–1970* (Paris: Contre-Moule/Paralleles, 1997). Available online at http://www.notbored.org/spur-manfesto1958.html. Erwin Eisch was a signing member of this manifesto.

27 Ibid.

28 In standard usage in Asia, family names precede given names.

29 Fujita Kyohei, "Me and Glass," *Glass Art Society Journal* (1998): 55.

30 Helmut Ricke, "Japan: A Dialogue Between West and East," lecture delivered at the symposium Quo Vadis? Glass Art in the Age of Globalization on the occasion of the Coburg Glass Prize, hosted by Kunstsammlungen der Veste Coburg and the Museum für ModernesGlas/CoburgerLandesstiftung, 2006. Available online at http://www.kunstsammlungen-coburg.de/glaspreis/symposium_ricke_e.html.

31 See Takeda Atsushi, "The 30th Anniversary of the Japan Glass Artcrafts Association," *Neues Glas* 1, no. 3 (Spring 2003): 24–31, for a discussion of the group's mission and activities.

32 Takeda Atsushi, "Kyohei Fujita and His Decorative Glass Caskets," *Neues Glas* 2 (April–June 1987): 70–71.

33 See Donald Keene, "The Tale of the Bamboo Cutter," *Monumenta Nipponica* 11, no. 4 (January 1956): 329–55, for a translation of the story.

34 Lynn, *Masters of Contemporary Glass*, 71. Although the program in Wausau was only a few hours away from Littleton's groundbreaking program at the University of Wisconsin–Madison, it was several months before Huchthausen would learn of the program. His early attempts at glassworking were significantly helped by this association, leading to his transfer to that program.

35 Huchthausen resume, Holsten Gallery Web site, http://www.holstengalleries.com/artists/show/huchthausen-10.

36 Mark S. Talaba, "Projection and Transformation: The Mysteries of Leitungs Sherben," *Neues Glas* (Fall 1983): unpaginated.

37 Huchthausen resume.

38 Found online at http://dict.tu-chemnitz.de/dings.cgi?lang=en&service=deen&opterrors=0&optpro=0&query=leitung&iservice=&comment=.

39 Robert Silberman, "David Huchthausen," *American Craft* (August/September 1987): 58.

40 David Huchthausen, *Americans in Glass* (Wausau, WI: The Leigh Yawkey Woodson Museum, 1984), 7–10.

41 Ibid., 3.

42 Robert Kehlmann discusses Cubism's influence on their work at length in his book *The Inner Light: Sculpture by Stanislav Libenský and Jaroslava Brychtová* (Tacoma: Museum of Glass, 2002), 11–14.

43 Robert Kehlmann, "Libenský/Brychtová: A Unique Collaboration in Glass," *American Craft* 54, no. 1 (August/September 1994): 44.

44 Marvin Lipofsky, transcript of an interview by Paul Karlstrom, Berkeley, California, July 30–31 and August 5, 2003, for the Nanette L. Laitman Documentation Project for Craft and Decorative Arts in America, the Archives of American Art, Smithsonian Institution, available online at http://www.aaa.si.edu/collections/oralhistories/transcripts/lipofs03.htm

45 Edris Eckhardt had led a glass course the previous summer.

46 Marvin Lipofsky, "From the Beginning: A Brief History of the Bay Area Glass Movement," *Glass Art Society Journal* (1994): 38.

47 Marvin Lipofsky, e-mail to Susie J. Silbert, July 25, 2008.

48 Marvin Lipofsky, in phone conversation with Susie J. Silbert, July 25, 2008.

49 Cheryl White, "Marvin Lipofsky: Roving Ambassador of Glass," *American Craft* 52, no. 5 (October/November 1991): 49.

50 Lipofsky, in phone conversation with Silbert, July 25, 2008.

51 Harvey Littleton, transcript of an interview by Joan Falconer Byrd, North Carolina, March 15, 2001, for the Nanette L. Laitman Documentation Project for Craft and Decorative Arts in America, Archives of American Art, Smithsonian Institution. Available online at http://www.aaa.si.edu/collections/oral histories/transcripts/little01.htm.

52 Joan Falconer Byrd, "Harvey Littleton," *American Craft* 59, no. 2 (April/May 1999): 48.

53 Warrington W. Colescott, "Harvey Littleton," *Craft Horizons* 19, no. 6 (November/December 1959): 22.

54 Susanne K. Frantz, "Not So New in '62," *Glass Art Society Journal* (1988): 15.

55 Martha Drexler Lynn, *American Studio Glass 1960– 1990* (New York: Hudson Hills Press, 2004), 54.

56 Susanne K. Frantz, *Contemporary Glass* (New York: Harry N. Abrams, 1989), 50–53.

57 Harvey Littleton, transcript of an interview by Joan Falconer Byrd, North Carolina, March 15, 2001, for the Nanette L. Laitman Documentation Project for Craft and Decorative Arts in America, Archives of American Art, Smithsonian Institution. Available online at http://www.aaa.si.edu/collections/oralhistories/transcripts/little01.htm.

58 In 1962, the classes were offered through the Ceramics Department, by the fall of 1963, glass had been added as its own class through the Department of Art and Art Education. Martha Drexler Lynn, "8 Days in Toledo," *Glass Magazine*, no. 98 (Spring 2005): 37.

59 See Dan Klein and Ward Lloyd, eds., *The History of Glass* (London: Orbis, 1984).

60 Byrd, "Harvey Littleton," 48.

61 Tina Oldknow, *Richard Marquis: Objects* (Seattle: University of Washington Press, 1997), 14.

62 Richard Marquis, as quoted in ibid., 17–18.

63 Susanne K. Frantz, as quoted in ibid., 23.

64 Marquis, as quoted in ibid., 28.

65 Richard Marquis, as quoted in Dan Klein, *Artists in Glass: Late Twentieth Century Masters in Glass* (London: Mitchell Beazley, 2001), 140.

66 Klaus Moje, "International Glass Education," *Glass Art Society Journal* (1984–85): 128.

67 Dan Klein, "Material Understanding and Chromatic Splendor: The Art of Klaus Moje," in *Klaus Moje* (Portland, OR: Portland Art Museum, 2008), 29.

68 Ibid., 34.

69 See Andrew Page, "Material Foundations," *Glass: The UrbanGlass Quarterly* 98 (Spring 2005): 26–31, for a discussion of the studio-glass program at Canberra School of Art.

70 James Yood, *William Morris: Myth, Object, and the Animal* (Virginia Beach, VA: Chrysler Museum of Art, 1999), 6.

71 William Morris, as quoted in Gary Blonston, *William Morris: Artifacts/Glass* (New York: Abbeville Press Publishers, 1996), 36.

72 Blonston, *William Morris*, 39.

73 Tina Oldknow, *William Morris: Rhytons* (Chicago: Riley Hawk Galleries, 1997), unpaginated.

74 Michael Boylen, "Compositions on Black: Joel Philip Myers," *American Craft* 40, no. 5 (October/November 1980): 8–9.

75 Joel Philip Myers has stated: "Had I not been aware of the Toledo glass seminars I wonder if I would have seen the dual possibilities of producing glass myself, while designing for the factory." See Myers's catalogue essay in *New American Glass: Focus West Virginia* (Huntington, VA: Huntington Galleries, 1976), 4.

76 Lynn, *Masters of Contemporary Glass*, 103.

77 Marvin Lipofsky, in conversation with Susie J. Silbert, July 25, 2008.

78 James Yood, "Joel Philip Myers," *American Craft* 59, no. 4 (August/September 1999): 41.

79  Dan Klein, "Joel Philip Myers," in *Joel Philip Myers* (Philadelphia: Wexler Gallery, 2007), 4.

80  Joel Philip Myers, in conversation with Susie J. Silbert, August 15, 2008.

81  Joel Philip Myers, quoted in Klein, *Joel Philip Myers*, 22.

82  Paul Hollister, "Monumentality in Miniature," *American Craft* 43, no. 3 (June/July 1983): 14.

83  William Warmus, *Tom Patti: Illuminating the Invisible* (Seattle: University of Washington Press, 2004), 36.

84  Hollister, "Monumentality in Miniature," 16.

85  Tom Patti, e-mail correspondence with Cindi Strauss, September 28, 2008.

86  Ibid.

87  Ibid.

88  Ibid. The sculpture is now in the collection of the Museum of Fine Arts, Houston.

89  Ibid.

90  Henry Halem, "G2001 Honorary Lifetime Member: Mark Peiser, Introduction," *Glass Art Society Journal* (2001). Available online at http://glassart.org/2001HonoraryLifetimeMember-Peiser.html.

91  Mark Peiser, in conversation with Susie J. Silbert, July 19, 2008.

92  Lynn, *Masters of Contemporary Glass,* 115.

93  Mark Peiser, "What, No More Dues?" *Glass Art Society Journal* (2001). Available online at http://glassart.org/2001HonoraryLifetimeMember-Peiser.html.

94  Dan Klein, "Compositions in Glass: The Art of Mark Peiser," in *Looking Within: Mark Peiser, The Art of Glass* (Asheville, NC: Asheville Art Museum, 2003), 11.

95  Peiser, in conversation with Silbert, July 19, 2008.

96  Franco Batacchi, "The Enfranchisement of Art Glass in the Works of a True Master," in *Livio Seguso: La Luce Nel Tempo Opere 1978–2007* (Milan: Editoriale Giorgio Mondadori, 2007), 55.

97  Enzo di Martino, "Livio Seguso: From Glass to Sculpture," in *Livio Seguso* (Milan: Editorale Giorgio Mondadori, 1998), 22.

98  Pierre Restany, "The Dazzling Play of Space and Light," in ibid., 7.

99  April Kingsley, "Mary Shaffer: Pioneer," *Glass: The UrbanGlass Quarterly*, no. 74 (Spring 1999): 31.

100  John Perreault, "Mary Shaffer: A Discourse on Innovation," http://www.maryshaffer.com/reviews.html.

101  Mary Shaffer, e-mail correspondence with Cindi Strauss, September 21, 2008.

102  Ibid.

103  Paul Stankard, *No Green Berries or Leaves: The Creative Journey of an Artist in Glass* (Blacksburg, VA: McDonald & Woodward, 2007), 11.

104  Paul Stankard, transcript of an interview by Doug Heller, New York, June 9 and August 20, 2006, for the Nanette L. Laitman Documentation Project for Craft and Decorative Arts in America, Archives of American Art, Smithsonian Institution. Available online at http://www.aaa.si.edu/collections/oralhistories/transcripts/stanka06.htm.

105  Lynn, *American Studio Glass*, 49. Both techniques were seen as both too small and too pedestrian for consideration.

106  Stankard, *No Green Berries or Leaves*, 49–66.

107  Paul Stankard, telephone interview by Karen S. Chambers, September 20, 1998, quoted in Karen Chambers and Tina Oldknow, *Clearly Inspired: Contemporary Glass and Its Origins* (San Francisco: Pomegranate, 1999), 90.

108  The term "magical realist" was first applied to Stankard's work by Ken Johnson, "Art in Review; Paul Stankard—'A Floating World,'" *New York Times*, July 16, 2004. Available online at: http://query.nytimes.com/gst/fullpage.html?res=9500E0DE153AF935A25754C0A9629C8B63&scp=1&sq=paul%20stankard&st=cse.

109  Ulysses Grant Dietz, *Paul J. Stankard: Homage to Nature* (New York: Harry N. Abrams, 1996), 32–36.

110  Paul Hollister, "Natural Wonders: The Lampwork of Paul J. Stankard," *American Craft* 47, no. 1 (February/March 1987), 42.

111  Dietz, *Paul J. Stankard: Homage to Nature*, 44–45.

112  Dane Stickey, "Glass Artist Therman Statom Moves his Renowned Career to Omaha," *Omaha World-Herald*, November 19, 2006. Available online at http://www.accessmylibrary.com/coms2/summary_0286-26702547_ITM.

113  Therman Statom, quoted in "Interview: Therman Statom, Thoughts, Ideas and Musings," *Glass Focus* 12 (October/November 1998): 15.

114  Therman Statom, from an interview with Susie J. Silbert, October 1, 2008, at the Littleton Studios, Spruce Pine, North Carolina.

115  John Drury, "Stolen Moments," *Glass Magazine*, no. 110 (Spring 2008): 43.

116  Statom, from an interview with Silbert, October 1, 2008.

117  Ibid.

118  Therman Statom resume, available online at http://www.thermanstatom.com/resume.html.

119  All biographical information from Suzanne K. Frantz, *Lino Tagliapietra in Retrospect: A Modern Renaissance in Italian Glass* (Seattle: University of Washington Press, in association with the Museum of Glass, Tacoma, 2008).

120  Tagliapietra was invited to Pilchuck after his brother-in-law, the glassblower Francesco Ongaro, who had taught there the previous summer, recommended him to Pilchuck's education coordinator, Benjamin Moore.

121  Concerning this mutual influence, see Lino Tagliapietra and Natalie de Combray, "Conversation," *Glass Magazine* 39 (1990): 12–13; and Richard Marquis, "Maestro Lino," *American Craft* 57, no. 6 (December–January 1997–98): 41–45.

122  Frantz, *Lino Tagliapietra in Retrospect*, 25.

123  Along the way have come several fruitful collaborations with other artists and designers, including Dan Dailey and Dale Chihuly, whose series of *Venetians* began with objects Tagliapietra created from Chihuly's drawings. For the artist's thoughts about such collaborations, see Lino Tagliapietra, "When There Is an Artist between the Glass and Me," *Glass Art Society Journal* (1994): 65–69.

124  Frantz, *Lino Tagliapietra in Retrospect*, 24.

125  Lino Tagliapietra's official Web site, http://www.linotagliapietra.com/batman/index.htm.

126  Jennifer Hawkins Opie, "Oiva Toikka: Sculptures," *Crafts*, no. 195 (July/August 2005): 58.

127  "Scandinavia's Young Dissenters," part of "Coming: Revolution in Scandinavian Design," *Craft Horizons* 18 (March 1958).

128  "Feelings transformed into jewels: Toikka does it again," Iittala Group Oy Ab, press release 10.5.C.11, February 2008, Helsinki, Finland.

129  Timo Simanaimen, *Oiva Toikka: Glass* (Riihimäki: The Finnish Glass Museum, 1988).

130  "Oiva Toikka: Bird Festival," press release, April 26, 2002, for an exhibition at the Arabia Museum, Helsinki, Finland.

131  Ibid.

132  Vallien met Peter Voulkos in Berkeley, and later stated that "to see the way Peter used the pure nature of clay without totally controlling it was a big eye-opener." See Matthew Kangas, "Turning Points: How Eight Artists Moved from Clay to Glass," *Glass: The UrbanGlass Quarterly* 88 (Fall 2002): 18.

133  Gunnar Lindqvist, *Bertil Vallien: Glass Eats Light*, trans. Angela Adegren (Stockholm: Carlsson Bokförlag, 1999), 105–7.

134  Ibid., 125–33.

135  "František Vízner Bio," Habatat Galleries, http://habatat.com/bio_popup.asp?ArtistID=131.

136  Antonín Langhamer, "Czech Specialized Schools for Glassmaking and Schools of Applied Arts: 1945–1990," in *Czech Glass 1945–1980*, 46.

137  Susanne K. Frantz, "Twentieth-Century Bohemian Art in Glass: The Artistic and Historical Background," in *Czech Glass 1945–1980*, 30–31.

138  Langhamer, "Czech Specialized Schools for Glassmaking," in *Czech Glass 1945–1990*, 54. Vízner's classically derived and austerely humanized vessels exemplify Štipl's call for a balance between form and decoration.

139  "František Vízner Bio."

140  František Vízner, "František Vízner," *The Glass Art Society Journal* (1984–85), 94.

141  "My New Yorkers understand me: with glass master Franitšek Vízner on loneliness and bad taste," *The Prague Post*, May 31, 2006. Available online at http://www.praguepost.com/articles/2006/05/31/my-new-yorkers-understand-me.php.

142  William Warmus, "Vízner's Vision," *Glass* 82
     (Spring 2001): 46.

143  Ann Wolff, in a phone conversation with
     Susie J. Silbert, September 30, 2008.

144  Robert Silberman, "Ann Wolff: Traditional
     Modernist," *American Craft* 67, no. 3
     (June/July 2007): 31.

145  Eva Schnitt, "Ann Wolff: A Retrospective,"
     *Neues Glas* 2 (Summer 2005): 15–16.

146  Amanda-Alice Maravelia, "Cosmic Space
     and Archetypal Time: Depictions of the
     Sky-Goddess Nut in Three Royal Tombs of
     the New Kingdom and her Relation to the
     Milky Way," *GM* 197 (2003), available online
     at: http://www.archive.gr/publications/
     culture/nut.pdf.

147  Silberman, "Ann Wolff: Traditional Modernist,"
     32.

148  Schnitt, "Ann Wolff: A Retrospective," 19.

149  Toots Zynsky, "Artist Profile," *Glass Work:
     A Quarterly Magazine on Glass* 1
     (April 1989): 23.

150  Originally these threads were created by
     hand, but in 1982, the Dutch designer
     Mathijs Teunissen van Manen, a friend of
     the artist, invented a machine that has
     since enabled Zynsky to more quickly
     produce thinner threads.

151  Toots Zynsky, Department of Decorative
     Arts Object Documentation Questionnaire,
     2000, The Museum of Fine Arts, Houston
     (MFAH), Curatorial Files.

152  Toots Zynsky, transcript of interview with
     Sandy Goldberg for an MFAH audio tour,
     MFAH Curatorial Files. After the vessels are
     formed, they are gradually cooled over
     several hours to prevent them from breaking.

153  Ibid.

# INTERVIEW WITH BARBARA AND DENNIS DUBOIS

## by Cindi Strauss

Cindi Strauss: Please describe your first encounter with contemporary glass. What role did it have in your decision to collect the material?

Barbara and Dennis DuBois: We had always collected—Herend porcelain, Baccarat animals, baseball memorabilia, and other things. Glass was just the next collection. We began collecting unique perfume bottles in 1985, and very quickly we were exposed to sculpture. It was the ingenuity of the artists and the variation in techniques that first attracted our attention; we loved the fact that, due to the creativity of the artists in developing new techniques, much glass sculpture did not look like glass—it could look like wood, stone, clay, or even mystery materials. And what appealed to us then, and still does today, is the constant mutability of glass—it is different in the morning than in the afternoon; it is different in the summer than it is in the winter; it is different when lit. The human eye cannot see anything without light, and glass is unique in that it is the only material that reflects, refracts, and absorbs light.

CS: How did you begin thinking about glass, and how have those thoughts changed over the years?

B & D: At first, we collected because we love beautiful things; it was only later that content became an important consideration and we realized we were collecting fine art. Glass has been fabricated for 2,500 years, and for most of that time it was used mostly for practical purposes and to a lesser extent as decoration. It is only in the last quarter of the twentieth century that glass came to be used to express the artist's ideas, thinking, feelings—content, if you will. Witness Libenský and Brychtova's *Silhouette d'un Ville* pieces, commemorating Czechoslovakia's Velvet Revolution against Communism; David Reekie's observations of the ironies of modern life; Steve Linn's odes to a long line of artists—musicians, poets, and painters; Ginny Ruffner's *Alien Serie*s, expressing her confusion and the contradictions inherent in trying to again understand the world after emerging from a coma. As in other media, some glass sculpture being made today remains decorative, but what a stunning level of decorative beauty it can achieve.

CS: How have you educated yourselves about glass and the artists working in the field?

B & D: The gallery owners played the most significant role in educating us originally. No question was too silly, and no time spent with us was too long. Subsequently, while we have read as much as possible in terms of books of collections, books of artists' work, and periodicals, our more in-depth education has come from visiting artists at their studios and understanding both their thinking and techniques. We have visited artists in Japan, Hungary, Poland, the Czech Republic, Venice, Germany, as well as throughout the United States, and we have never been denied a requested visit. Glass artists are the most welcoming group, anxious to share their excitement for this medium by discussing their work and demonstrating their techniques. Another great opportunity to learn has been the biennial Glass Weekend in Millville, New Jersey; we have attended every weekend since 1987, and aside from watching stars like Dale Chihuly, William Morris, Richard Marquis, and others blow glass, we have learned a great deal from the two days of panel discussions each year. Those discussions have covered a myriad diverse topics: methods of display and lighting, the secondary market for the resale of glass, insurance issues, museum-curator panels comparing individual pieces of glass sculpture with other pieces of fine art in their institutions' collections, and artist's presentations, to name a few.

CS: How would you describe your connection to glass? Is it emotional, spiritual, intellectual, or a combination of the three?

B & D: It is a combination of the emotional and the intellectual. Some pieces, even ones we have owned for twenty years, to this day overwhelm us with their pure beauty, reflecting the creative genius of the artist. Other pieces reflect the thoughts, frustrations, and desires of the artists.

CS: Glass is a very technical medium. Balancing technique and content is always a challenge for the artist. Is this also a consideration for you when choosing work for your collection?

B & D: We do not consciously attempt to balance the technique and content of a given piece or the collection as a whole. For the most part, our collection is made up of pieces that startled us at first sight—maybe because of the idea the artist expresses, maybe because of the beauty, maybe because of the "how did he or she do that" factor.

CS: Please describe some of your most exciting moments in collecting.

B & D: So many of our pieces have a stories attached. One example: we fell in love with a suspended Bertil Vallien boat one year at Glass Weekend; unfortunately for us, the piece was already sold. A year later, we walked into the Heller Gallery in New York, and Doug Heller told us that the collector who had purchased the piece subsequently decided to trade up for a larger piece, that the piece had been on display at the Morristown Museum of Art for six months, and that it had been returned to the gallery only the day before. It was meant to be ours. Also, it is very exciting to see pictures of our pieces published, as happened recently when our Dan Dailey *Fool* was pictured on the cover of *Glass* magazine.

CS: How much of the collection do you live with on a regular basis? How has living with the work changed your life?

B & D: We live on a day-to-day basis with somewhere in the neighborhood of 250 to 275 pieces on display. Sculpture is in every room in our home, including bathrooms. And the most exciting thing to us is that we never get tired of it. We do move pieces from time to time so our view is fresh, but our collection is part of the family.

CS: Your collection is mostly encyclopedic, but you do collect certain artists in depth. Why?

B & D: Our collection is composed of work by approximately 160 artists from all over the world. We do, however, have a significant concentration of the work of Richard Marquis, Dan Dailey, and William Morris. We never set out to do that. We have never set out to acquire an artist's work so that we could say we have a piece by him or her. We just kept coming back to these three because they always "startled" us, whether because of the technique (Morris) or the sense of humor—as well as technique—in their work (Marquis and Dailey). The by-product of this attraction is that we now have a vertical tasting of their careers—great examples of work from their early years to the present—examples of how they have morphed and grown throughout their careers.

CS: Do your personal relationships with artists affect your collecting? What do you gain from these relationships and the access to information and/or the studio visits that often accompany them?

B & D: We never acquire a piece simply because we like an artist; having said that, as we mentioned, the artists working in this medium are almost universally approachable, and we know at least 75 percent of the artists in our collection. They have always been willing to share their knowledge in helping us understand their work. We think it a bonus to acquire a piece when we have firsthand knowledge of both the technique and the artist's thinking. One of our most memorable visits was to the home of Tom Patti in western Massachusetts early in our collecting career. Tom brought out a single piece

from each year of his glassmaking life. To see the development of technique and direction was a revelation. Another was a visit to the studio of Shinichi and Kimiake Higuchi outside of Tokyo, where we came to understand the enormous complexity of their *pate de verre* work.

CS: Please discuss your involvement in glass collector groups. What do you feel is the role of these groups—and are they helpful? Are there trips or experiences that you have had with fellow collectors that have been particularly meaningful to you?

B & D: As a couple, we are involved in the Art Alliance for Contemporary Glass (AACG), and Dennis is a member of the boards of the AACG and the Creative Glass Center of America (CGCA), the home of Glass Weekend. The AACG is a group of people who either collect or are simply interested in the medium and whose purpose is to promote glass sculpture as fine art, primarily by making grants to museums to help defray the expense of exhibitions of glass sculpture, as it has done in connection with this exhibition. The CGCA board, made up of collectors, artists, curators, and gallery owners, promotes the medium by providing grants to young artists from around the world, allowing them to come to New Jersey, and, at no expense to them, to live and work in the Center's hot shop to make their work and develop their techniques. Needless to say, everyone in both organizations is an ardent supporter of contemporary glass sculpture, and we have made many wonderful friends through those organizations. Also, while there is no formal local collectors' group in Dallas, we often open our home to groups—many of whom have never experienced this medium—who express interest in seeing the collection. We have also traveled extensively with the AACG, as well as with the annual Habatat Galleries Glass Lovers' Tour, visiting Japan, Prague, Venice, Budapest, Frauenau, Seattle, and New England, among others, and have made great friends from all over the country in doing so. It is comforting to know that there are others out there as obsessed as we are, who buy work when they have no room whatsoever to display it, and who never fail to breach their resolution not to buy anything on this trip. For years Barbara has toyed with the idea of starting a group to offer counsel to those so afflicted.

CS: The glass world has grown and developed immensely since you began collecting. Has this changed the way you think about your collection? Has your interest been piqued by any recent developments in glass?

B & D: The contemporary glass world has grown exponentially since we began collecting in 1985. There are many more galleries, some showing glass with other mediums, more university programs, more artists, and more collectors. The best evidence is the growth of attendance at Glass Weekend and SOFA Chicago over the last decade. And the most exciting thing today is the emergence of the next generation of young artists who, building on the work of the pioneers in this exhibition, have truly taken this art form to the next level. Just look at the work by Oben Abright and April Surgent as examples. Another thing is the number and reputation of artists who work in other mediums who are now working with glass, such as Albert Paley, Jun Kaneko, and Nicholas Africano. Also, because we began collecting relatively early on—the studio glass movement did not really exist until the 1970s—we have a reasonable representation of pieces from the early years, but we have recently acquired a good number of pieces at auctions and in private sales to fill in gaps.

CS: How does it feel to watch the glass movement grow? Do you feel like you are participating in the process of creation through your collecting?

B & D: We feel as though we have a vested interest in this art form. We all like to feel vindicated in our beliefs, and we think the growth of this medium over the last twenty years has done just that. We are proud to have been a part of this, and we do feel that our collecting has in some small way allowed a young artist to have enough support to continue to develop his or her technique. And it is exhibitions of the type the MFAH is doing with *Pioneers of Contemporary Glass* that further will expose our passion to the person who appreciates art but who has never had the occasion to view contemporary glass sculpture.

# CHECKLIST OF THE EXHIBITION

All works are in the collection of Barbara and Dennis DuBois, except where noted.

1    Howard Ben Tré
American, born 1949
*Structure 30*
1986
Cast glass and copper
48 x 14 x 12 inches
(121.9 x 35.6 x 30.5 cm)

2    Dale Chihuly
American, born 1941
Untitled from the *Seaform* series
1989
Blown glass
6 x 13 x 16 inches (15.2 x 33 x 40.6 cm);
5 x 5 x 9 1/2 inches (12.7 x 12.7 x 24.1 cm);
7 1/2 x 6 x 13 inches (19.1 x 15.2 x 33 cm);
7 1/2 x 6 1/2 inches (19.1 x 16.5 cm);
3 x 3 inches diameter (7.6 x 7.6 cm diameter)

3    Václav Cigler
Czech, born 1929
*Untitled* from the *Egg* series
1990
Cast glass
8 1/2 x 11 1/2 inches
(21.6 x 29.2 cm)

4    Dan Dailey
American, born 1947
*Fool* from the *Individuals* series
2004
Blown glass
12 1/2 x 14 1/2 x 19 inches
(31.8 x 36.8 x 48.3 cm)

5    Dan Dailey
American, born 1947
*View of Lust*
1983
Vitrolite and blown glass
28 x 35 1/2 inches
(71.1 x 90.1 cm)

6    Erwin Eisch
German, born 1927
*Globeman with Astronauts*
1999
Mold-blown glass
18 x 12 x 7 inches
(45.7 x 30.5 x 17.8 cm)

7    Kyohei Fujita
Japanese, 1921–2004
*Taketori Tale*
2000
Blown glass, gold, and silver
4 1/8 x 4 1/2 x 4 1/8 inches
(10.5 x 11.4 x 10.5 cm)

8    David Huchthausen
American, born 1951
*LS83G* from the *Leitungs Scherben* series
1983
Glass and Vitrolite
12 x 10 x 19 inches
(30.5 x 25.4 48.3 cm)

9    Stanislav Libenský
Czech, 1921–2002
**Jaroslava Brychtová**
Czech, born 1924
*Spaces VI*
1995
Cast glass
20 x 41 x 9 1/4 inches
(50.8 x 104.1 x 23.5 cm)

10    Marvin Lipofsky
American, born 1938
*Kentucky Series #8*
2000–2001
Blown glass
16 x 17 x 17 inches
(40.6 x 43.2 x 43.2 cm)

11  Harvey Littleton
American, born 1922
*Red/Blue C Form*
1989
Blown glass
12 1/2 x 12 x 4 inches
(31.8 x 30.5 x 10.2 cm);
2 1/2 x 6 1/4 x 3 inches
(6.4 x 15.9 x 7.6 cm)

12  Richard Marquis
American, born 1945
*Bubbleboy NZ5*
1988
Blown glass and paint
27 x 13 1/2 x 10 inches
(68.6 x 34.3 x 25.4 cm)

13  Richard Marquis
American, born 1945
*Marquiscarpa #11*
1991
Glass
6 x 8 x 4 3/4 inches
(15.2 x 20.3 x 12.1 cm)

14  Richard Marquis
American, born 1945
*Oil Can #7*
1993
Blown glass and found objects
51 1/2 x 21 1/2 inches diameter
(130.2 x 54.7 cm diameter)

15  Klaus Moje
German, born 1936
*Untitled*
1989
Fused glass
10 1/4 x 10 1/4 x 2 1/2 inches
(26 x 26 x 6.4 cm)

16  William Morris
American, born 1957
*Untitled* from the *Suspended Artifact Series*
1995
Blown glass and metal
38 x 27 x 5 inches
(96.5 x 68.6 x 12.7 cm)

17  William Morris
American, born 1957
*Untitled Bull* from the *Rhyton Series*
1996
Blown glass
16 x 22 x 9 inches
(40.6 x 55.9 x 22.9 cm)

18  Joel Philip Myers
American, born 1934
*CFD White Long Hol* from
the *Fish and Water Series*
1988
Blown glass
9 1/2 x 28 x 3 inches
(24.1 x 71.1 x 7.6 cm)

19  Tom Patti
American, born 1943
*Expanded Echo with Line*
from the *Echo Series*
1989
Glass
2 1/2 x 6 x 4 inches
(6.4 x 15.2 x 10.2 cm)

20  Mark Peiser
American, born 1938
*Hollyhocks and Butterfly* (PWV 45)
from the *Paperweight Vase Series*
1977
Blown and cased glass with torch-worked imagery
6 1/4 x 6 1/4 inches diameter
(15.9 x 15.9 cm diameter)

21  Livio Seguso
Italian, born 1930
*Estasi*
2000
Blown glass and Bardilio marble
18 x 17 1/4 x 7 inches
(81.3 x 43.8 x 17.8 cm)

22  Mary Shaffer
American, born 1947
*From Cube IV*
1992
Glass and bronze
32 x 9 1/4 x 5 3/4 inches
(81.3 x 23.5 x 14.6 cm)

23  Paul Stankard
American, born 1943
*Untitled*
1990
Glass
5 5/8 x 2 3/4 x 2 7/8 inches
(14.3 x 7 x 7.3 cm)

24  Therman Statom
American, born 1953
*Chair*
c. 1992
Glass with mixed media
53 x 48 x 32 inches
(134.6 x 121.9 x 81.3 cm)
The Museum of Fine Arts, Houston,
gift of Barbara and Dennis DuBois,
2008. 450. A-.C

25  Lino Tagliapietra
Italian, born 1934
*Batman*
1998
Blown glass
14 x 9 x 3 inches
(35.6 x 22.9 x 7.6 cm)

26  Oiva Toikka
Finnish, born 1931
*Lemon Road*
1989
Cast glass
53 x 6 1/4 x 5 inches
(134.6 x 15.9 x 12.7 cm)

27  Bertil Vallien
Swedish, born 1938
*Pendulum V*
1992
Cast glass and metal
87 1/4 x 13 5/8 x 13 5/8 inches
(221.6 x 34.6 x 34.6 cm)

28  František Vízner
Czech, born 1936
*Untitled*
1993
Glass
3 1/2 x 11 3/4 x 11 3/4 inches
(8.9 x 29.9 x 29.9 cm)

29  Ann Wolff
German, born 1937
*Nut's Daughter*
1987
Glass, enamel, and metal
79 x 26 1/2 x 6 inches
(200.7 x 67.3 x 15.2 cm)

30  Toots Zynsky
American, born 1951
*Lady in a Blue Chair*
from the *Tierra del Fuego* series
1990
Filet-de-verre (fused and
thermoformed glass threads)
10 x 7 x 5 1/4 inches
(25.4 x 17.8 x 13.3 cm)

# ADDITIONAL ARTISTS REPRESENTED IN THE BARBARA AND DENNIS DUBOIS COLLECTION

Abright, Oben

Africano, Nicholas

Allen, Rik

Amann, Jean

Babcock, Herb

Bachorik, Vladimir

Beck, Rick

Begou, Francis

Bennett, David

Bernstein, Alex

Bettison, Giles

Blank, Martin

Blomdahl, Sonia

Bohus, Zoltan

Borowski, Pawel

Borowski, Stani Jan

Borowski, Stanislaw

Bothwell, Christina

Bowman, Jim

Braunstein, Stuart

Burke, Ellie

Carlson, William

Cash, Sydney

Chardiet, José

Chaseling, Scott

Clark, Jon

Clayman, Daniel

Clegg, Tessa

Cohen, Carol

Cribbs, Kéké

Dane, Robert

DiFiore, Miriam

Donefer, Laura

Edwards, Stephen Dee

Elias, Bohumil

Fero, Shane

Frolic, Irene

Frydrych, Jan

Gessell, Polly

Glancy, Michael

Grebe, Robin

Guggisberg, Monica, and Philip Baldwin

Handl, Milan, and Stanislava Grebeníčková

Heaney, Colin

Heilman, Chris, and Joyce Roessler

Higuchi, Kimiake

Higuchi, Shinichi

Hilton, Eric

Hlaviača, Tomáš

Holmes, Kathleen

Hopper, David

Hora, Petr

Hřebačkova, Petr

Hutter, Sidney

Iezumi, Toshio

Ikuta, Niyoko

Jensen, Judy

Jolley, Richard

Kallenberger, Kreg

Karbler, Kit, and Michael David

Karel, Jiří

King, Gerry

Klumpar, Vladimira

Kohler, Lucartha

Kuhn, Jon

Künster, Gabriele

LaMonte, Karen

Langley, Warren

Langston, Nancy

LaScola, Judith

Levin, Rob

Lewis, John

Linn, Steve

Long, JP

Loughlin, Jessica

Luebtow, John Gilbert

Lugussoy, Maria

Lukácsi, László

Mace, Flora, and Joey Kirkpatrick

MacNeil, Linda

Marioni, Dante

Maslach, Steven

Mason, Concetta

Meitner, Richard

Melcher, Mihály

Mickelson, Robert

Miner, Charles

Moore, Benjamin

Murray, David

Musler, Jay

Novák, Břetislav Jr.

Odahashi, Masayo

Ohira, Yoichi

Paley, Albert

Palusky, Robert

Pavlik, Michael

Perkins, Danny

Perkins, Flo

Peszko, Wojciech

Pohlman, Jenny, and Sabrina Knowles

Powell, Stephen Rolfe

Priour, Damian

Randal, Seth

Reekie, David

Rijsdijk, Meza

Ritter, Richard

Roach, Carola Nan

Rogers, Sally

Rosol, Martin

Ruffner, Ginny

Russel-Pool, Kari

Salvadore, Davide

Scoon, Thomas

Shaw, James

Singletary, Preston

Spera, Carmen

Statom, Thermon

Stern, Hubert

Stone, Molly

Summa, Henry

Surgent, April

Takahashi, Naoki

Takahashi, Yoshihiko

Tobin, Steve

Tóth, Margit

Trabucco, Victor

Urushiyama, Misaki

Van Cline, Mary

Van Duerzen, James

Velliky, Cristen

Vitkovsky, Janice

Walentynowicz, Janusz

Weinberg, Steven

Wenzel, Walter

Whiteley, Richard

Wingfield, Leah

Wolfe, Jon

Yamano, Hiroshi

Yang, Loretta

Yokoyama, Naoto

Zoritchak, Jan

Zuber, Czeslaw

# SELECTED BIBLIOGRAPHY

Note to Reader: In addition to phone interviews and correspondence with many of the artists in the exhibition, the authors also utilized the oral histories in the Nanette L. Laitman Documentation Project for Craft and Decorative Arts in America at the Smithsonian Institution's Archives of American Art.

Due to the large number of monographs and articles on glass artists, this bibliography focuses on general sources.

*American Glass Now*. Toledo, OH: The Toledo Museum of Art and New York: Museum of Contemporary Crafts, 1972.

*Americans in Glass*. Wausau, WI: The Leigh Yawkey Woodson Art Museum, 1981.

Chambers, Karen S., and Tina Oldknow. *Clearly Inspired: Contemporary Glass and Its Origins*. Petaluma, CA: Pomegranate Communications, 1999.

*Contemporary European and American Glass from the Saxe Collection*. Oakland, CA: The Oakland Museum, 1986.

Dietz, Ulysses Grant. *The Art of Glass from Gallé to Chihuly: Highlights from the Lowenbach Collection*. Newark, NJ: The Newark Museum, 2007.

Fairbanks, Jonathan L., and Pat Warner. *Glass Today by American Studio Artists*. Boston: Museum of Fine Arts, Boston, 1997.

Fox, Howard N. *Glass: Material Matters*. Los Angeles: Los Angeles County Museum of Art, 2006.

Frantz, Susanne K. *Contemporary Glass*. New York: Harry N. Abrams, 1989.

Hawley, Henry H. *Glass Today: American Studio Glass from Cleveland Collections*. Cleveland: The Cleveland Museum of Art, 1997.

Ilse-Neuman, Ursula. *Four Acts in Glass*. New York: American Craft Museum, 1997.

Klein, Dan. *Glass: A Contemporary Art*. London: William Collins Sons & Co., 1989.

Koplos, Janet. "World Glass Now '85." *American Craft*, no. 46 (February/March 1986): 10–17.

Littleton, Harvey K. *Glassblowing: A Search for Form*. New York: Van Nostrand Reinhold Company, 1972.

Lynn, Martha Drexler. *American Studio Glass 1960–1990: An Interpretive Study*. New York: Hudson Hills Press, 2004.

_____. *Sculpture, Glass and American Museums*. Philadelphia: University of Pennsylvania Press, 2005.

Lynn, Martha Drexler, and Barry Shifman. *Masters of Contemporary Glass: Selections from the Glick Collection*. Indianapolis: Indianapolis Museum of Art, in association with Indiana University Press, 1997.

Miller, Bonnie J. *Out of the Fire: Contemporary Glass Artists and Their Work*. San Francisco: Chronicle Books, 1991.

Oldknow, Tina. *Pilchuck: A Glass School*. Stanwood, WA: Pilchuck Glass School, 1996.

_____. *25 Years of New Glass Review*. Corning, NY: The Corning Museum of Glass, 2005.

Opie, Jennifer Hawkins. *Contemporary International Glass*. London: V & A Publications, 2004.

Ricke, Helmut, ed. *Czech Glass 1945–1980: Design in an Age of Adversity*. Stuttgart, Germany: Arnoldsche Art Publishers, in association with the Museum Kunstpalast Düsseldorf, 2005.

*Viva Vetro! Glass Alive!: Venice and America*. Pittsburgh: Carnegie Museum of Art, 2007.

# COPYRIGHT CREDITS

The Museum of Fine Arts, Houston, has made every effort to contact all copyright holders for objects reproduced in this book. If proper acknowledgment has not been made, we ask copyright holders to contact the museum. We regret any omissions.

© Howard Ben Tré, courtesy of the artist; page 20

© Dale Chihuly; pages 18, 22–23

© Václav Cigler, page 24

© Dan Dailey; pages 26, 29, 84

© Erwin Eisch; page 30

© The estate of Kyohei Fujita; pages 6, 33

© David Huchthausen; page 34 Photograph by Roy Adams

© Jaroslava Brychtová and the estate of Stanislav Libenský; page 37

© Marvin Lipofsky; cover and page 39

© Harvey K. Littleton; page 40

© Richard Marquis, pages 42, 44–45

© Klaus Moje; page 47

© William Morris; pages 48, 50–51

© Joel Philip Myers; page 53

© Tom Patti; page 54

© Mark Peiser; page 57

© Livio Seguso; page 58

© Mary Shaffer; page 61

© Paul Stankard; pages 62–63

© Therman Statom 2009; page 64

© Lino Tagliapietra; pages 2, 66

© Oiva Toikka; pages 68–69

© Bertil Vallien; pages 70–71

© František Vízner; back cover and page 73

© Ann Wolff; page 74

© Toots Zynsky; pages 77, 88